ARCHITECTURAL PHOTOGRAPHY

Eric de Maré

B. T. Batsford Limited
London and Sydney

First published 1975

Copyright © Eric de Maré 1975

ISBN 0 7134 2985 2

PHOTOTYPESET BY TRADESPOOLS LTD, FROME, SOMERSET

PRINTED AND BOUND IN GREAT BRITAIN BY
THE PITMAN PRESS, BATH

for the publishers B. T. Batsford Limited
4 Fitzhardinge St., London W1H 0AH and
23 Cross Street, Brookvale, N.S.W. 2100, Australia

Introduction

Appreciation of architecture is often supposed to lie in knowledge about old styles, names and dates, and this tends so to bore the layman that he shuts his eyes. Thus he misses much direct sensual pleasure that has nothing to do with antiquarian scholarship – a pleasure to be found in the basic architectural elements of all the ages: strong forms, lively proportions, rich textures, unifying rhythms, enlivening contrasts, honesties in purpose and use of materials, and interesting play with space.

The Camera's Scope

So this small work is not concerned with styles as such or with their temporal cosmetics. Here the word architecture is used in its widest sense to reveal by example the architectonic and photogenic qualities to be found, by those who possess a camera and have eyes to see, in all kinds of structures built in different ages – as well as in anything from an immutable townscape to a piece of street furniture, even where no architecture in the conventional meaning of the word was intended. As I wrote in *Photography and Architecture* (Architectural Press, 1961), 'The camera, roving and selecting within its circumscribed manner and field of view, can open the eyes. It can reveal, for example, the drama of contrast when the low evening sun strikes hard at a row of white timber cottages standing against a thunder-black sky; the luscious, tactile quality of the worn, wet stones of a breakwater seen very close; the geometric pattern of the members of a great steel bridge silhouetted against the clouds; the rigid rhythm of windows in a wall to which the baroque decoration of a twisting tree serves as a foil; the enticing perspective down the passage of an ancient town with its suggestion of something interesting to be explored around the

3

bend. In short, the architectural qualities of things and places. . . . Once you feel those qualities, especially the textures and colours of materials and the sculptural and spatial forms they make, you will begin to see all things in a fresh way, as directly and vividly as a child does'.

The photographing of sculpture has been included here, not only because sculpture often embellishes a building as an integral enrichment (in mediaeval cathedrals in particular) but also because the problems of lighting and composing a piece of sculpture in the viewfinder are similar to those encountered in photographing buildings in whole or in part. Not only does sculpture possess visual affinities with architecture, but so also does photography itself, for all three media are concerned with constructing forms, lines, tones, textures, and possibly colours into sculptured unities. (It may be significant that the first two photographs ever taken were of buildings.) A photograph which is more than a record and makes an attempt by selection, framing and composition to create a telling whole, is itself, if at a remove, a kind of architectural work because it is a complete and therefore beautiful structure – a structure built with the raw material of light.

Yet, in a way, photography is unlike any other creative medium, and it is particularly potent when dealing with architecture because through selection to make firm compositions by judicious choice of viewpoint, of lighting, and of lens of particular focal length, and in processing and printing, it can make personal comment – most often by isolating a detail from its surroundings and building a disciplined structure in its own right within the frame. The camera can select significant, organized form from the general chaos of the world, and in black-and-white it can formalize reality in a range of tones between black and white that creates a kind of abstract. The camera, although in many ways like an eye, does not see in quite the same way as an eye, and so it presents a paraphrase, or transmutation, of reality.*

* Here I am concerned only with straight photography in tonal black-and-white and in colour, although any method which uses the effect of light on a surface made sensitive to light may be called photography, such as the photogram or through the technique of photographics (sometimes called posterization) which eliminates

4

A special quality of photography is, of course, its power to capture in an organized form the fleeting moment that will never recur, and which drawing and painting are too slow to achieve. As a famous editor of a picture magazine said, 'The camera is an instrument for netting life'. That quality is not of great concern in architectural work with its static approach but sometimes it can be useful there when moving objects such as human figures are needed to complete the picture.

The camera can also capture atmospheric mood through quality of light and angle of view, even to a point of romanticism. How to define the two approaches of romantic and classic? The question has some bearing on our subject. Romanticism relies on association and atmosphere, on evocative, dreamy mood. It has a taste for exotic escape and is essentially literary (*roman, a tale*). In excess it leans towards the sentimentality of the pathetic fallacy. Classicism depends on controlled form. Roger Fry summarized: 'I call romantic any work of art which to produce its effect counts on the association of ideas which it sets up in the mind of the spectator. I call classical the work which to provoke emotion depends on its own formal organization'. It follows that, as a general rule, architectural photography must lean towards classic form even if the subject be romantic.

What is Art?

In aesthetics, the question arises: What makes a work of art in any medium, even in the limited one of photography? It is an ancient question and some mystery remains. Here are a few brief attempts at definition. A work of art is the creation by a single personality from which nothing can be deducted and nothing added without weakening or destroying the moving and expressive impact it seeks to communicate. It is thus in a sense a universal and life-enhancing symbol of that integrity for which every living entity is striving – a wholeness that has resolved

tones and reduces a photograph to lines, dots and pure blacks and whites. This can be fun but it carries the photographic medium into the area where drawing and engraving begin to be more appropriate. *Photographics* by Pär Lundqvist (Focal Press, 1973), which I translated from the Swedish, is a good, practical handbook on the subject.

destructive conflict. It is a symbol, therefore, of that psycho-physical, ultimately inexplicable, desire of all living things to survive. As Sir Herbert Read once wrote, 'Our homage to an artist is our homage to a man who by his special gifts has solved our emotional problems for us'. Art is thus therapeutic both for societies and individuals. Visual art, in fact, originated in pre-history in sympathetic magic as part of the ritual of survival — that is, with the hunting and growing of food and with fertility. (At the same time, it seems that creating a visual pattern is a satisfying end in itself which even some cossetted monkeys enjoy. The genetic function of DNA that conveys life's order in a single sperm is based on a minute piece of abstract sculpture called the Double Helix.)

Even in the humble rôle of photographer, a man or woman can become an artist by selecting vitalizing forms, and thereby can solve emotional problems. In the end we are surely all potential artists, desiring the whole, the hale, as a protest against the void of death.

How then to express what you feel in your visual explorations as fully as possible? You need as much technical knowledge as you can gain in order to understand the effects on the emulsion of lighting, film, filter, lens, diaphragm stop, shutter speed, processing, printing, and so on. But technique is only a means to an end; the end is personal expression and for that you need an eye for composing. That is partly the result of training and intellect but ultimately it is one of intuition. Sensibility is far more valuable than beguiling technical brilliance. Obsession with apparatus should be avoided. 'The way to get at it', wrote John Piper, the famous painter who is also a brilliant photographer, 'seems to me to be to ask oneself not "how can I take a good photograph", but "what do I like enough to make me want to photograph it?".'

Neither technique nor composing can be fully discussed in this brief work, (For fuller information try my two Penguin Handbooks, *Photography* and *Colour Photography*) but here are a few brief tips both on composing and on technique which are particularly applicable to architectural photography. The captions to the pictures also have something to say on these matters.

Composing

Although any work of art, even a photograph which attempts to be more than a mere record, must form an ordered unity, wholeness is not enough; it must contain tensions and diversities that are resolved if it is not to be boring and lifeless. The watchwords are Contrast, Repetition, Balance, Climax. One must always bear in mind Ruskin's comment: 'It is impossible to give rules that will enable you to compose. If it were possible to compose pictures by rule, Titian and Veronese would be ordinary men'. Yet some canons can be defined as points of departure for intuition. Asymmetry is generally more interesting than precise symmetry, although every rule exists to be broken. The most powerful place for the focal, binding, climax of interest is never near the middle and becomes the more powerful the nearer it approaches the corners of the frame; then it needs balancing with some weighty object on the other side. A strong sense of spatial depth can be provided by including a close foreground object, preferably dark in tone. Avoid the unresolved duality, say by cutting a picture in half with a straight line such as an horizon. Avoid large areas of dullness, such as grass or gravel, unless you badly need them as foils. Use a vertical format for vigour and drama, horizontal for repose, and square for bold, matter-of-fact statement, perhaps of a detail. And never make more than one statement at a time; do not, for example, try to portray in one exposure a person and a building both of equal value, or unresolved conflict will result.

The Three Kinds of Architectural Photography

Architectural photographs do not all care about composition or show any creative pretensions. They can be divided into three sorts, which may overlap in their intentions. The first is the pure Record, the visual survey, which makes no claim to creativity but merely tries to convey as much information about a building as possible. This is dull, useful work for which a certain technique has been established, and which I have outlined in my *Photography and Architecture*.

The second sort is the Illustration which serves both as a

good record and also forms a pleasing picture in its own right. Here careful composing is essential, and it is the professional's bread-and-butter work by which he seeks to flatter a building, as in a portrait, and to make his own visual comment upon it. It presents a subject in as attractive, and perhaps as dramatic, a way as possible so that the viewer will remark in the same breath, 'What a lovely building', and 'What a splendid photograph'.

The third category I call the Picture. This is unconcerned with record but solely with creating a telling, architectonic composition whether the subject is of an architectural nature or not. This category provides great enjoyment for here you can discover architecture in strange places, perhaps through a microscope, perhaps in a strata of rock, a jumble of box lids, a rotting doorway, or piled cranks in a pottery works. Here the selected close detail comes into its own.

The Three Views of Architecture

The appreciation of architecture in itself can also be categorized into three kinds which overlap: Façade, External Form, Internal Space. These may be said to be respectively two-, three- and four-dimensional – the last called so because time enters into the appreciation.

Façade is like a painting in a way, or like an architect's elevation drawing; although in a sense it is two-dimensional the third dimension enters in a limited way to provide modelling and texture. This may well be a directly frontal view of the whole or of part of a building or of a street. Here side lighting is valuable in stressing the modelling and texture.

External Form is strongly three-dimensional, and it is like sculpture in that it can be appreciated by wandering around *outside* the structure and understanding it from different points of view. The way the light falls is important in stressing the three dimensions – generally by allowing the light to illuminate some planes while leaving the remaining planes in shadow. A position should be taken where one series of planes dominates the others, which means that a view of 45° towards the right-angles of the walls should be avoided.

Façade and External Form enclose space; and they shut out space. The third category, Internal Space, deals with the control and manipulation of spatial relationships themselves whether for purely practical or for symbolic, emotional purposes – or both. It includes the achievement of contrasts, for instance, between spaces: small and large, low and high, straight and curving. These may evoke feelings of cosiness and protective domesticity, grandeur and awe, mystery, complexity, monumentality, religious aspiration. Even a town may be regarded in this *internal* way in that streets serve as corridors, open spaces as rooms, façades as inner wall surfaces, and sky as a roof. This spatial aspect may be called four-dimensional in that time is essential to its full appreciation as the human body wanders through the spaces as though through a varying landscape where changes of level may also be involved.

Photography can admirably express the external aspects of structures and their combinations by representing the three dimensions on a two-dimensional surface, but internally it is at some loss because the four dimensions cannot be fully represented in two – except by implication. Even a movie camera cannot wander around on two feet, turning head and shoulders, rolling eyes, as a human body can. This is a limitation in the photographic expression of architecture and it must be accepted. By clever lighting and choice of viewpoint spatial relationships can be suggested in a single photograph, but that is all. With the help of a drawn plan having arrows upon it and a series of photographs taken at the arrowheads, an understanding of internal spatial relationships in a particular building or town can be indicated more fully than with a single shot; yet some imagination is then necessary to convey the effects of the total interior. Actuality can be enjoyed only by the roving body. As G. K. Chesterton remarked, 'Art is limitation; the essence of every picture is the frame'.

Colour Photography

Of course colour photography is invaluable for pure recording where the communication of information is the aim. Although this view may not be popular, I believe that in creative photog-

raphy black-and-white wins aesthetic laurels in competition with colour, particularly in architectural work. For one thing, colour photography tends to be too naturalistic, often to a garish degree. Is anything more repellent, for example, than the combination of postcard-blue sky with vivid green grass below it? Nature is by no means always an artist. Black-and-white formalizes, abstracts and paraphrases more readily than colour and is thus more personally selective, controlled, and interesting. Black-and-white stresses forms, tones and textures, whereas colour can distract the eye from these and weaken the structural entity. The discovery of good form in combination with good colour is rare, for colours in the surroundings tend to be unrestricted, too variegated and rarely harmonious or significant. The palette, as painters say, should be restricted in any telling colour composition. This is particularly difficult in the wide view but far easier in the close one.

The eye must see differently when photographing in colour because here contrasts are achieved less by tonal variations than by complementary colours. On the whole fairly neutral colours are better than saturated ones, although a point of brilliance can be introduced with effect at a focal point as a foil to the surrounding neutrality.

Colour transparencies certainly possess a special charm of their own on account of their translucence, but a colour print is flatter and its surface texture is rarely pleasing – perhaps because one unconsciously desires the tough texture of canvas and paint. In black-and-white, moreover, far greater personal control is possible in composing, as well as in processing and printing, while the exposure latitude is wider. Enlarging is far easier too, and can be done by the amateur at home without a large and complicated dark-room, whereas processing and printing in colour is a laborious and costly chore which is usually left to the mechanized mass-production trade. Perhaps colour comes into its creative own not only in the very close view but also by deliberate distortion and control with coloured lamps and filters.

Cameras

Every art requires its own technique and a few words on this matter which are of particular use in architectural photography conclude this essay. First, what is the best type of camera to use? Any camera will do provided its limitations are understood, but some types of camera give wider scope and greater freedom than others. My own ideal does not exist; it would be a single-lens reflex taking $2\frac{1}{2}$ in. square negatives on 120-size roll film, having interchangeable lenses and film holders, with both automatic and manually operated control of aperture and shutter, and with TTL (through the lens) light metering. The Hasselblad comes close to the ideal but it lacks that great boon in architectural photography – the rising front which helps you to include the whole of a tall structure without sloping the camera, which will produce weakly converging verticals.

Of available cameras what is the best type? The 35 mm. single lens reflex is admirable for taking transparencies for projection on to a screen – this is the kind so many people carry on their holidays abroad. It is particularly useful for taking a long series of record shots, of a building under construction for example. Again a rising front is missing, although this can be overcome to some extent by using a special lens which has a rising screen in which a small hole is pierced. For making fine, big enlargements either in colour or in black-and-white, the 35 mm. (or the smaller Kodak Instamatic) is not ideal because the negative is so small and will tend to reveal grain and blemishes such as dust specks and scratches that require much tedious touching out. An advantage of the 35 mm. camera is that it can be fitted with a zoom lens whereby different focal lengths can be obtained with one object.

The $2\frac{1}{4}$ in. square such as the Hasselblad, or the twin lens such as the Rolleiflex, or the $2\frac{1}{4}$ by $3\frac{1}{4}$ in. hand-or-stand bellows camera is better for architectural work than the 35 mm. miniature. The hand-or-stand type, such as the Linhof Technica, has rising front and other movements; lenses can be interchanged and so can film holders in case you want to use different kinds of film on the same subject. But even this kind has its faults and limitations. The professional generally chooses a mono-rail camera such as the Arca or Sinar, both Swiss made, taking 4 by

5 in. cut film in holders. Here you have every possible movement and, of course, lenses and plates are rapidly interchangeable. As with the hand-or-stand type, viewing can be either through a viewfinder (possibly with focusing mechanism) or on a ground-glass screen at the back before film or plate holder takes its place; then, of course, a tripod is essential. An advantage of the large mono-rail type is that a roll-film adaptor taking 120-size film can be inserted if smaller negatives are wanted, and also a considerable extension of movements, not least of rising front, is possible since the coverage of the lens is greatly increased; another advantage is that the focal length of the lens is naturally reduced, a wide angle lens becoming in effect one of medium focal length, and one of medium length becoming one of long focus. A drawback of the 4 by 5 in. plate camera is its large size and weight so that the user often needs a small trolley for its transport. With its different lenses and so on it also tends to be costly and will be purchased only by the most dedicated amateur.

For the more casual amateur perhaps the single-lens $2\frac{1}{4}$ in. square reflex is the best choice in spite of lack of rising front, or at any rate the twin-lens reflex. The twin-lens poses a problem in the close-up owing to the parallax correction needed between the viewing lens and the exposing lens; special lenses can be attached to correct this and sometimes parallax correction is built in.

Various ways of overcoming lack of rising front can be adopted. Tilting a camera upwards in order to include the whole height of a tall structure creates those weakly converging verticals in the image which, to my taste, should always be avoided since they deny the very essence of structure: stability. (A deliberate and exaggerated slope as in a so-called worm's eye view is a different matter and quite legitimate.)

Converging Verticals

The chief method of overcoming this problem is to use a wide-angle lens with its broad vision, keeping the camera quite level; too much foreground can be cut away when printing. Another possibility is to take a position high up, say on a hillside or on

the upper storey of a suitably situated building facing your subject. The third possibility is to take your shot with camera sloping upwards and then bring the verticals back to the parallel when enlarging by sloping the base-board of the enlarger on which the paper is placed, or turning the lens holder of the enlarger to a slope, or doing both; then, of course, the lens stop must be small in order to eliminate blurring of the image at each end, which will be out of focus with the centre; some enlargers, in fact, overcome this problem by mechanical means. It must be realized that in adjusting verticals during enlargement part of the image at the two sides of the negative must be cut away as triangles and cannot appear on the print; allowance for this must be made when exposing. And some distortion of proportions will occur; the building will look slightly taller than it is in fact, not usually with any aesthetic loss. (A matchbox with its three heights can serve well to tilt the base-board.)

Camera Movements

Of these the rising front is the most valuable; the use of the others such as sliding front are rarely necessary. With rising front the lens can be raised with its holder so that more of the top part of the subject appears on the bottom part of the film when exposing; here a tripod and focusing screen may have to be used when viewing. Thus the camera does not need to be sloped upwards and all verticals remain parallel and upright. Covering power of lenses is limited so that the amount of rise of the front must also be limited; if raised too far the top of the image on the print will show a rapidly blackening arc where light has not penetrated. (The same effect may result when using the rising front with a lens hood of insufficient size; if in doubt, remove the hood before exposing.)

Other movements are the dropping front which is used to maintain verticals of a subject situated below the horizontal, perhaps when you are standing on a hillside or a rooftop. The sliding front has the same effect though not up or down but on either side, and this is useful if you wish to obtain horizontal lines, say of a façade going off in perspective either to left or right, or if you want to include part of a façade which is un-

obtainable in a direct view.

Then there is the swing, or hinged, back by means of which you can slope the film or plate holder, perhaps in extreme cases with the additional aids of rising front and wide-angle lens. Then the camera can be sloped upwards without disturbing the verticalities. A small diaphragm stop must then be used or part of the image may be out of focus. A special virtue of the swing back lies in the opportunity it provides of photographing a fairly close subject that runs rapidly away in perspective; then the slope of the back will help the focusing of close and distant parts of the subject even when a fairly wide stop is used.

Lenses

A single lens, whether wide angle or medium in focal length, suffices for most purposes, but the ideal is to own at least three lenses: wide angle (short focus), medium, and long focus. The variations of focal length can be simply explained thus: Look out of a window far back in a room; the view you see will represent that of a long-focus lens. Stand closer and you will have the view of a lens of medium focal length. Stand very close and you will have the view of a wide-angle lens. Both medium and wide-angle views will contain at their centres what the long-focus lens will see, and the wide angle will also contain what the medium lens will see. If, on the other hand, you go outside the room and try to obtain with a wide-angle lens what the long-focus lens saw inside the room by getting close to the subject, you will fail, for your image will be quite different. If you wish to obtain dramatic contrasts in scale and height use a lens of long focus at a distance; a close view with a wide-angle lens will reduce contrasts of heights of different objects while widening the apparent distances in depth between them.

The wide-angle lens is particularly useful for interiors and it provides considerable depth of field so that the need for a very small diaphragm stop is reduced when overall sharpness of focus is wanted. When the width of angle is extreme distorted effects result which are not always pleasing or revealing, but a lens of reasonably wide angle is the most useful of all lenses in architectural photography.

A long-focus lens is valuable for taking distant details or townscapes. It has, as already noted, a foreshortening effect and it provides a limited depth of field so that great care must be taken in focusing, preferably on a tripod, and care must also be taken to avoid camera shake or vibration of tripod when exposing because any movement will be greatly exaggerated as compared with that recorded by a medium or wide-angle lens. A telephoto lens is a kind of long-focus lens in the extreme; its uses are limited and it is a costly, weighty item. It requires even more careful focusing and steadiness than the normal long-focus lens. (A large stone or other heavy weight hung from the tripod head will help steadiness.)

Filters

In black-and-white, a single yellow filter requiring double exposure is sufficient. This is mainly needed to bring out the blue of the skies and to correct the tonal values of panchromatic film in daylight. A crack-of-doom effect in skies can be obtained by using a red filter that demands an increase of exposure of seven times, but it is rarely needed; dark blue sky is produced far less by filtering than by a clear atmosphere and by the angle of the sun because the sky darkens as the sun falls behind the camera; it also darkens if the camera is pointed upwards. When using photoflood lamps, filtering is not necessary on panchromatic film, although exposure will have to be doubled to deal with lack of blue rays in the light. With colour film always use a haze filter to cut out ultra-violet light and excess of blue; this demands no increase of exposure.

Accessories

A tripod is essential for good architectural photography if only to avoid camera shake; held in the hand a camera may not be steady enough even at 1/50th-second exposure. A tripod also enables you to compose carefully on a screen. The tripod should be sturdy to avoid wind shake and other vibrations; it should have a universal joint at the head so that the camera can be

15

pointed firmly in any direction. Its legs should be telescopic to give as tall a stand as possible even if the height means that you must stand on a wall or a box when sighting. A central shaft that can be moved readily up and down is an asset. Another valuable accessory is a good light meter. So too is a lens hood, used to cut out unwanted light which might reduce contrast of tones.

Lighting

This is of immense importance. During the day sunlight is generally needed for strong results although it would be foolish to be dogmatic on this point. Study of the angle at which the sunlight falls is necessary so that the qualities of form and texture are fully revealed. The sun is in effect a huge single lamp shining through a dome of diffusion, and it can be at its most revealing early on a clear morning or late in the evening when it casts long shadows, particularly if the light falls from the side to stress forms and textures.

For interiors or objects such as monuments inside a building photoflood lamps may be needed, though natural, available light may often be the better. Then slight over-exposure and over-development will increase contrast if the light is flat. I abhor flash lighting myself, whether from bulbs or an electronic device. I never use it because it produces harsh shadows and a soot-and-whitewash effect when used near the camera, and its precise effects are unpredictable. Floodlamps can be arranged to give the exact effects you want before you expose and the light can be measured with a meter on the understanding that a doubling of exposure shown by the meter is needed. (If an exposure is long, reciprocity failure must be taken into account and the exposure increased because light has progressively less effect on film emulsion as time passes.)

Two floodlamps with reflectors are useful, and if soft light is required one of those white umbrellas the photographic shops provide can be a help in spreading the light by reflection. My most valued lamps are two enormous white bowls on sturdy, collapsible stands on wheels which can be raised to a height of twelve feet and take 1000 watt bulbs; small discs cover the lamps themselves if desired to provide a general light. With these,

any subject from a great hall to a door handle can be well lit.

A general rule when using two or more lamps is to allow one lamp to dominate the others so that shadows can be produced if desired without blocking or harshness. In photographing sculpture rigid rules cannot be applied; moving the lamps about experimentally until the effect seems right is the best method. Light reflected from a white sheet or white wall or ceiling can be effective, especially when photographing bronze – a difficult material owing to the spotty highlights. (Some photographers, indeed, spray the bronze before exposure with a sort of harmless dust in order to reduce the scintillations.)

When contrasts are excessive in an interior, as for example the view through a window surrounded by a dark wall, the problem is usually solved by flood-lighting the wall. The effect can be somewhat artificial and another solution exists which I have learned from my friend, photographer Fred Lammer: Wildly over-expose, perhaps by ten times or more, and wildly under-develop.

Films

All the well-known makes serve well, the general rule in black-and-white being that the slower the film the less grain it will show. Try different films and then settle on those which you prefer for your purposes. Mostly I use 120-size Kodak Verichrome Pan for black-and-white, and Kodak Royal-X if I need great speed. For colour in daylight I use Agfachrome 50S Professional, and for photoflood lighting Agfachrome 50L Professional, admirable films which allow up to fifty seconds exposure without throwing colours out of balance as a result of reciprocity failure.

In the end the best way to acquire a technique is to learn it by trial and error. Experience, they say, is cheap at any price.

The Illustrations

These have been selected to interpret the word architecture as widely as possible and at the same time to serve, it is hoped, as

17

stimulating exemplars of the art of building with light. Unless acknowledgement is given in the captions all the photographs are mine, most of them having been previously published either in my own or other authors' books. I must acknowledge my debt to my old *Alma Mater,* the Architectural Press, and to its contributors to the *Architectural Review,* for many of the ideas and phrases used here.

TOWNSCAPE: Architectural design is not confined to single buildings and their detailing; it includes their juxtaposing in streets, neighbourhoods and whole towns for aesthetic as well as functional purposes, to form agreeable urban scenes. *Below,* a remarkable pattern of mediaeval gables at Freudenberg, Germany, clearly taken with a lens of long focus *(Reinhard Siegel, In-Bild, Bonn).*

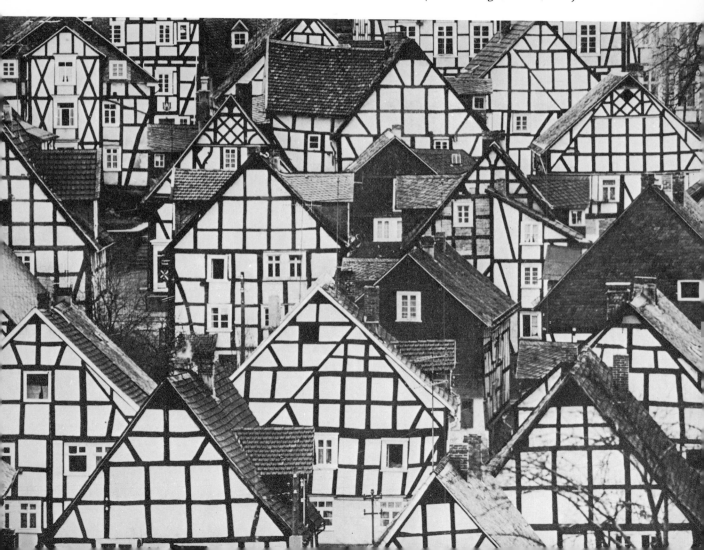

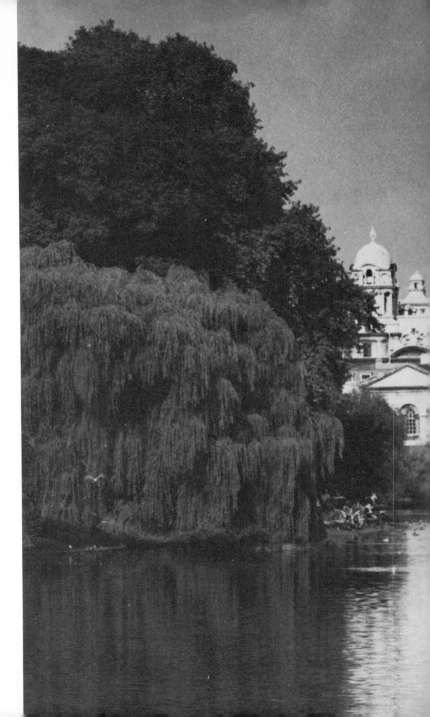

TOWNSCAPE: One of the world's most enchanting and quite unpremeditated townscapes: Whitehall seen across the lake of St James's Park, London *(Linhof, long-focus lens, part of negative only).*

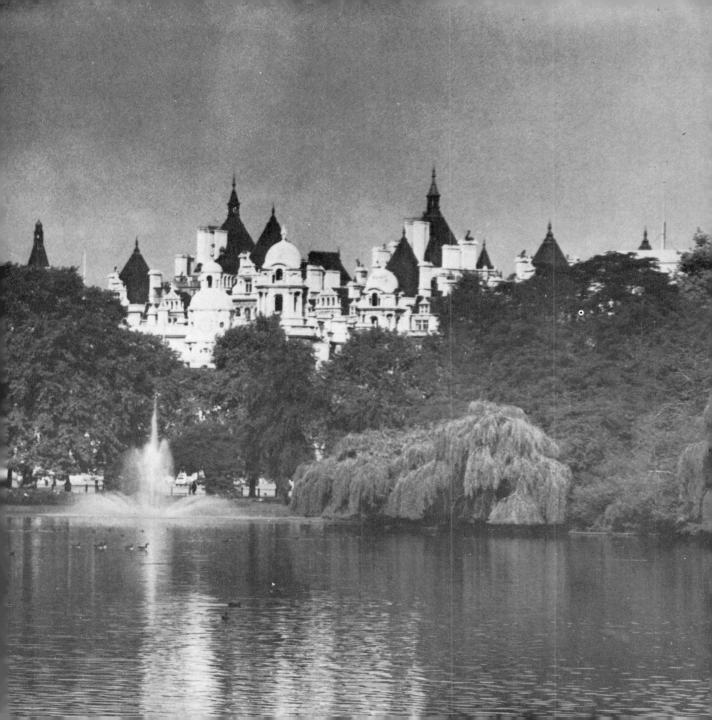

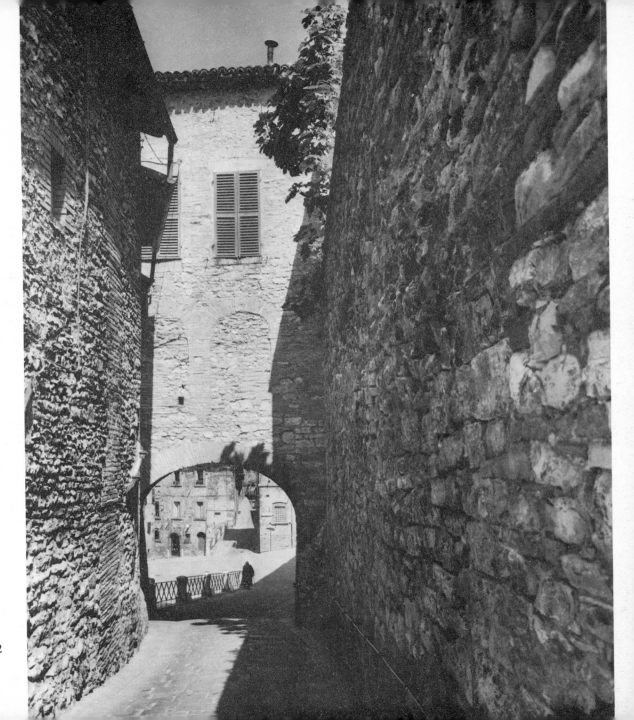

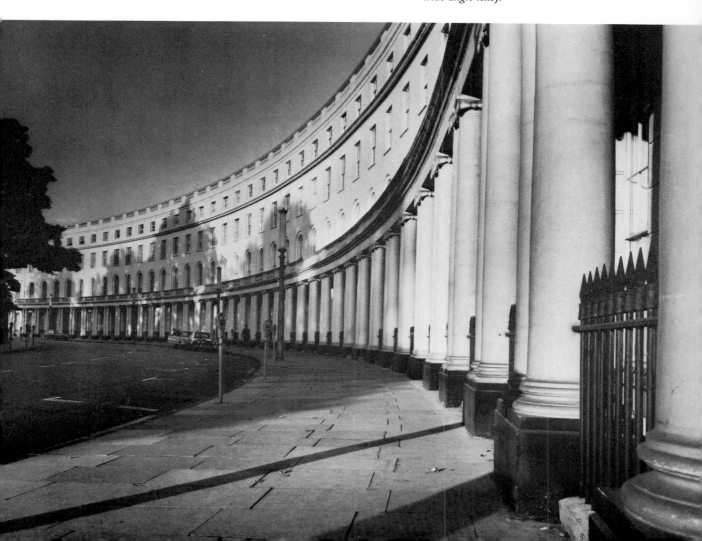

TOWNSCAPE: Mediaeval romance and Georgian classicism. *Left*, framed and closed vista at Assisi. *Below*, Nash's Park Crescent, London *(Both Linhof, wide-angle lens)*.

TOWNSCAPE IN SILHOUETTE: Serrated skyline is stressed and tonal details are understated, a visual feature of more importance in the grey north than in the sunny south. *Right,* Scott's St Pancras Station Hotel at sunset, a romantic shot of romantic revivalism yet one having firm classic form. Only part of the negative was·used and this gave a grainy look expressing the sooty London of the Railway Age; no faking, though the sky was 'burned in' during enlarging *(Rollei). Below,* Edinburgh Castle in the evening *(Rollei, the lower part of negative being cut away during printing).*

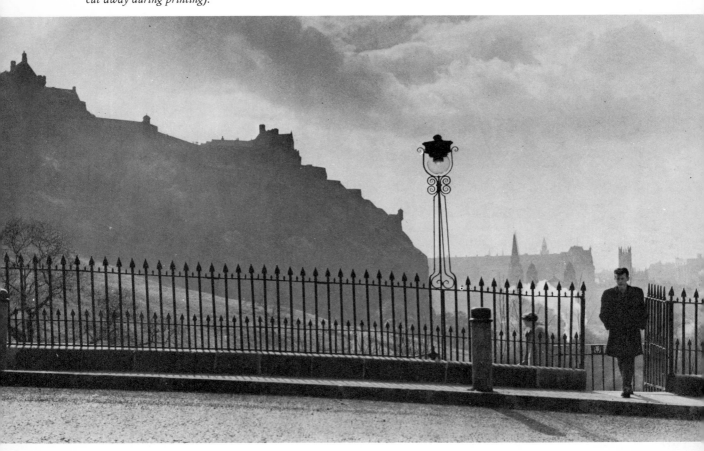

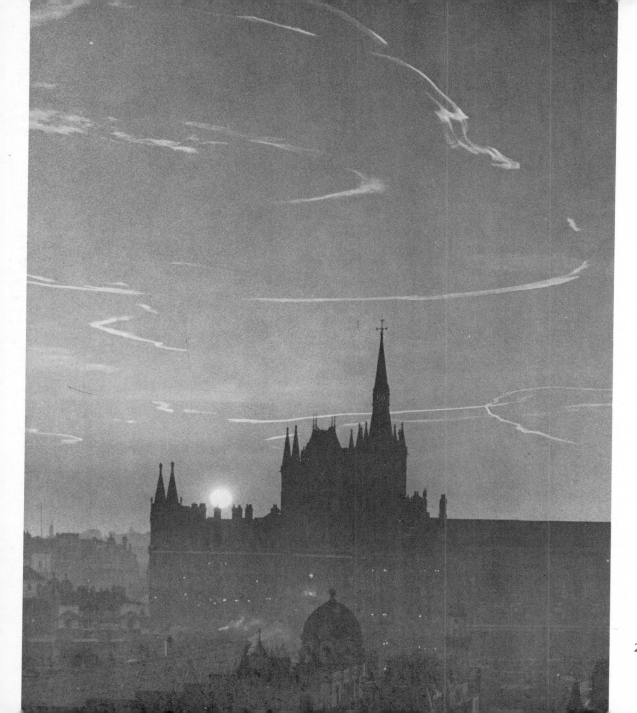

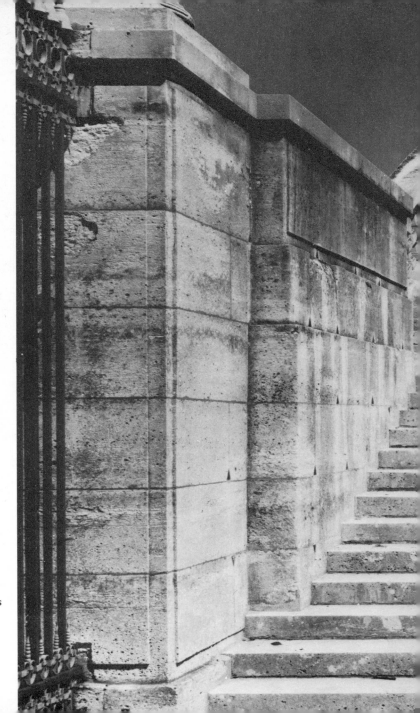

CHANGES OF LEVEL: An important element in buildings and townscapes is the variation of levels, possibly linked by steps. *Right,* the grand staircase at Versailles Palace with tiny figures giving scale. The truncation of building at top right stresses the levels and hints at the marvels of regal splendour to be revealed, it is hoped, at the end of the heroic climb *(Linhof, wide angle).*

26

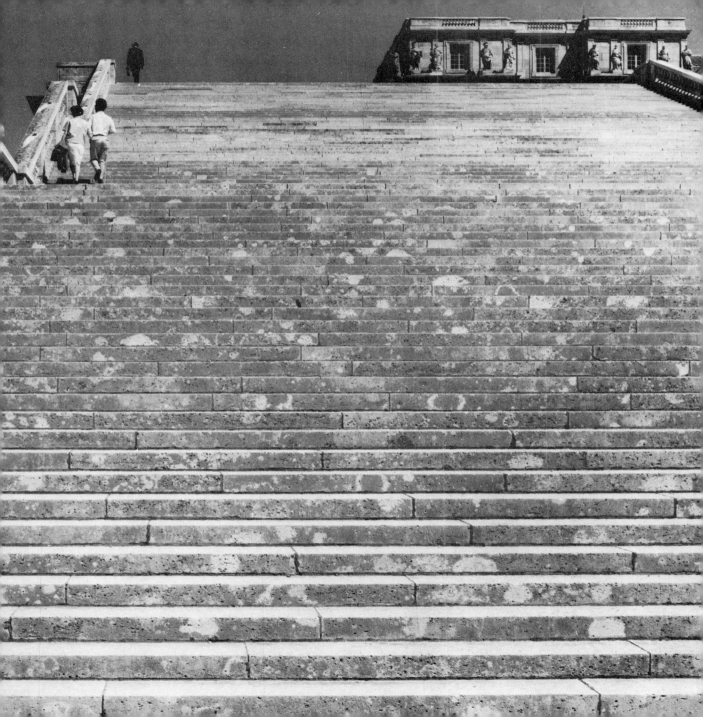

CHANGES OF LEVEL: Towns built on slopes like Assisi, Edinburgh, and the hill towns of Provence are far more visually interesting than those built on plains. *Below*, a composition of steps at Clifton, near Bristol *(Rollei)*. *Right*, Edinburgh *(Linhof, wide angle)*.

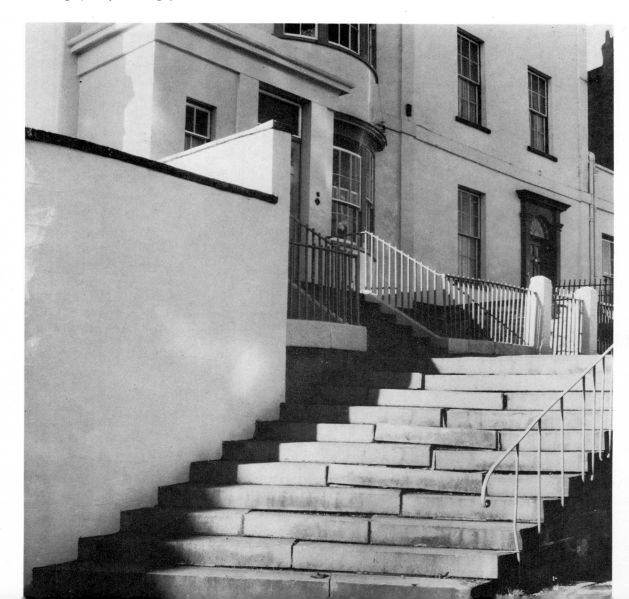

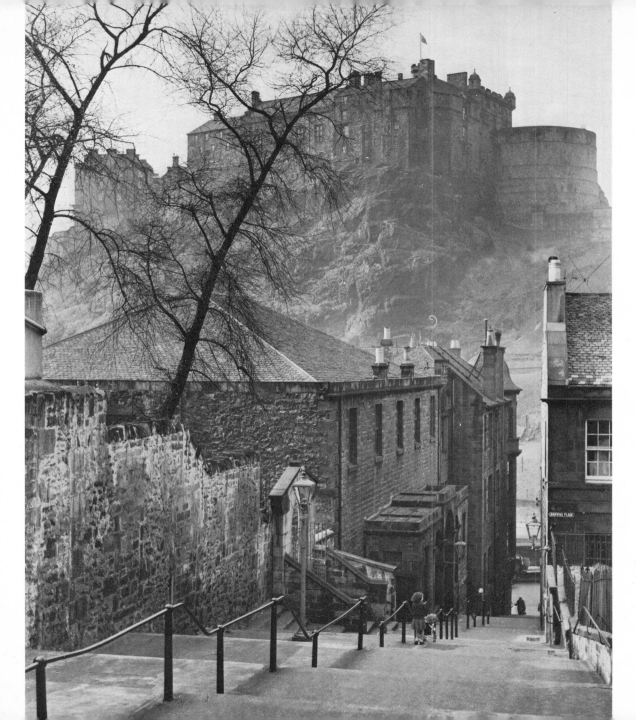

MONUMENTALITY: Buildings and their lay-out may be called monumental when they symbolize some aspiring social or religious creed through a sense of solidity, permanence and grandeur of scale. At its worst monumentality expresses vainglorious tyranny. Symmetry is frequent but not essential, and even utility structures can sometimes achieve an unintended monumentality. London, being largely a tolerant collection of congealed villages, is not notable for monumentality, but it does contain a few examples. *Below,* the Duke of York's Column and steps at the southern end of Nash's *Via Triumphalis*, or Metropolitan Improvement, that runs up to Regent's Park *(Linhof, wide angle). Right,* St Paul's Cathedral taken from the steeple of St Bride's. Note the slim, dark steeple on the left deliberately placed there by Wren as a foil to his great, swelling dome *(Linhof, medium lens).*

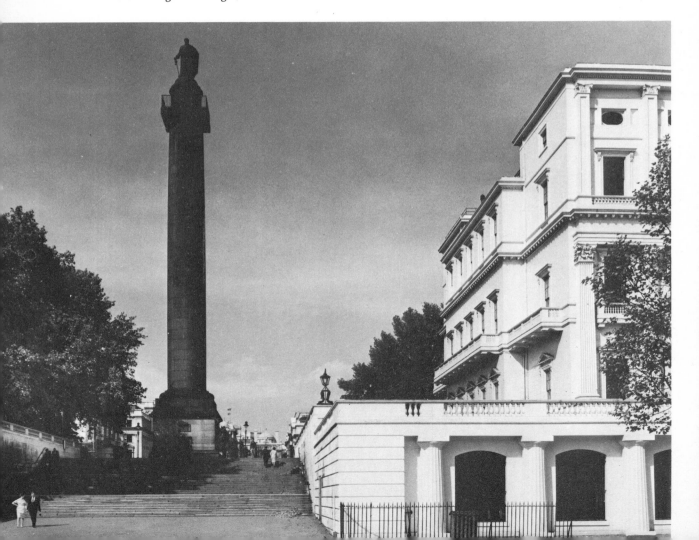

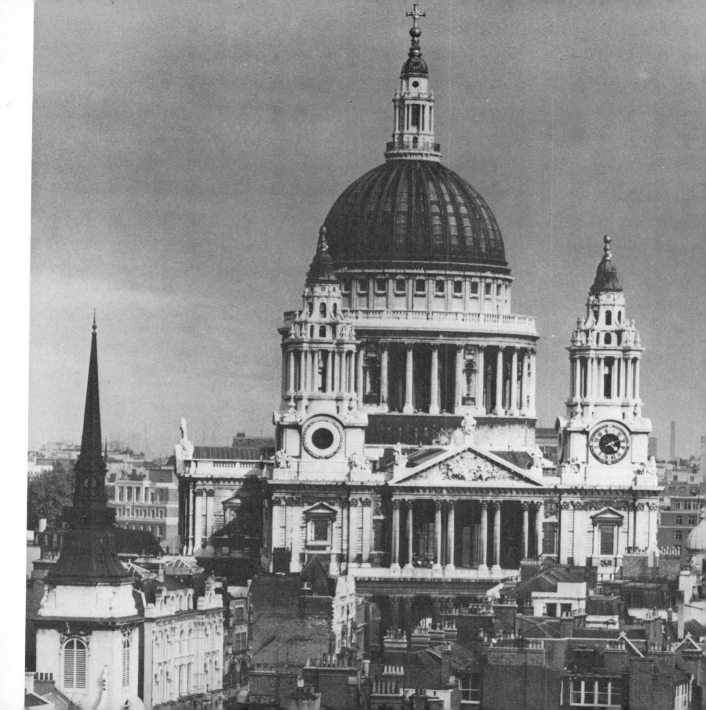

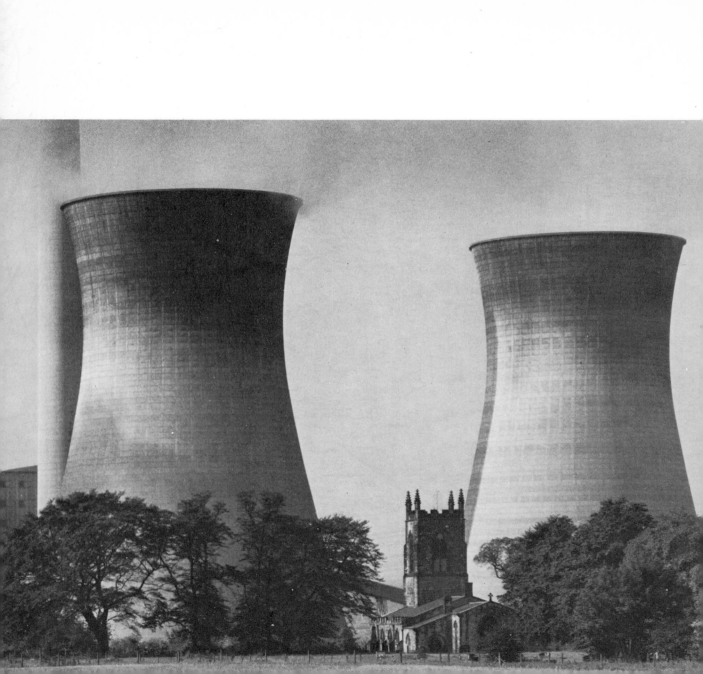

SHARAWAGGI: An eighteenth-century word denoting the picturesque combination of period styles. *Left,* water coolers at Ferry Bridge power station, Yorkshire, dramatized in scale by the inclusion of a mediaeval parish church *(Linhof, long focus).* A closer view with a wide-angle lens would have reduced the drama of scale. *Right,* top of the Tudor gatehouse of St James's Palace, London, with a modern office tower block under construction in the background. This was taken from the upper end of St James's in Piccadilly and only a small part of the negative was used so providing the impressionistic grain *(Linhof, long focus).*

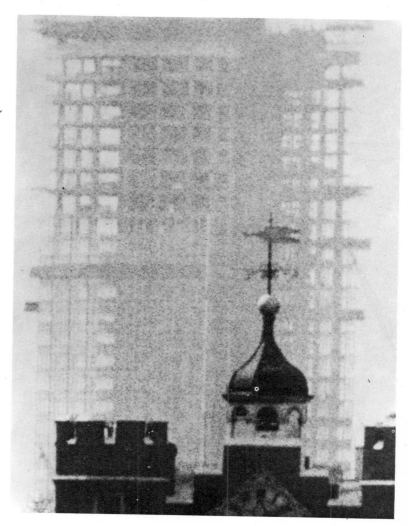

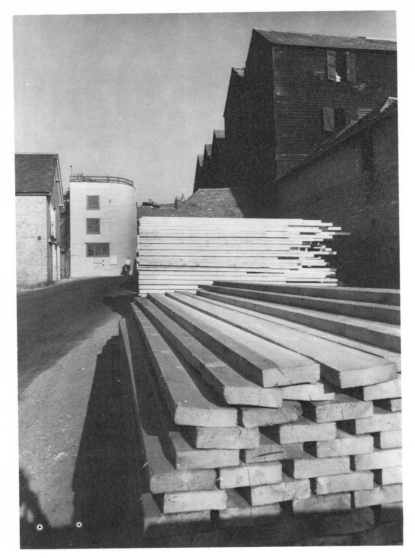

PERSPECTIVE: Lines and planes running away rhythmically to the distance can form pictorial structures having powerful spatial depth, particularly when tones are in contrast. *Left,* timbers and old warehouses at Rye, England. *Right,* an arched roof of Paddington Station, London. Here a slightly sloped camera was permissible since a few vertical lines intrude *(Both Linhof, wide angle).*

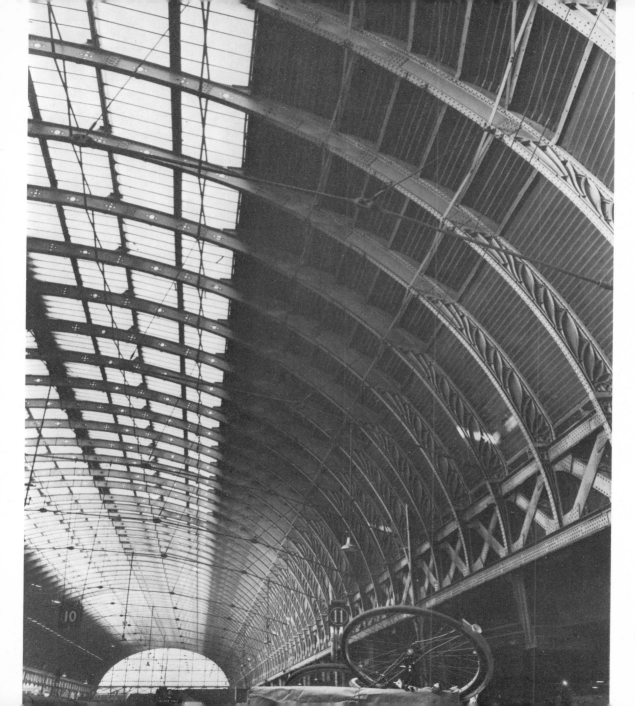

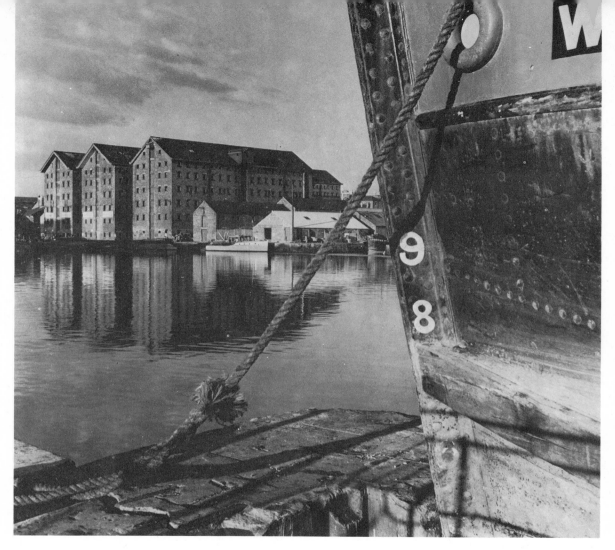

DEPTH OF FIELD: A valuable trick to stress three-dimensional depth is to include an object in the close foreground, preferably dark in tones. If the near object is to be in focus with the distant ones a small stop must be used and a comparatively long exposure, while the near object, being heavy, should have a balance of interest on the other side of the picture. *Above*, the fine brick warehouses of Gloucester Docks, England, with a ship's bow in foreground to provide spatial depth, interest and balance *(Rollei)*. *Right*, Victory Arch, Hyde Park Corner, London, with part of a military memorial in the foreground to make not only a balanced composition but a moral comment *(Linhof, wide angle)*.

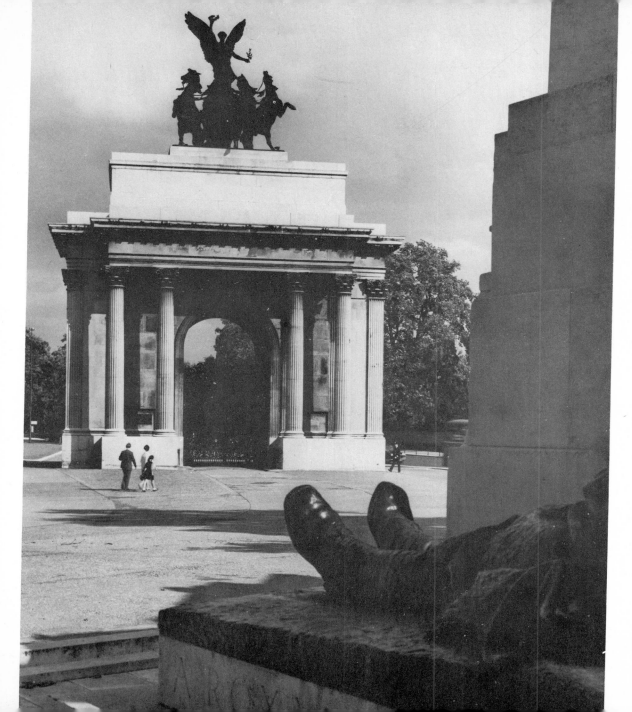

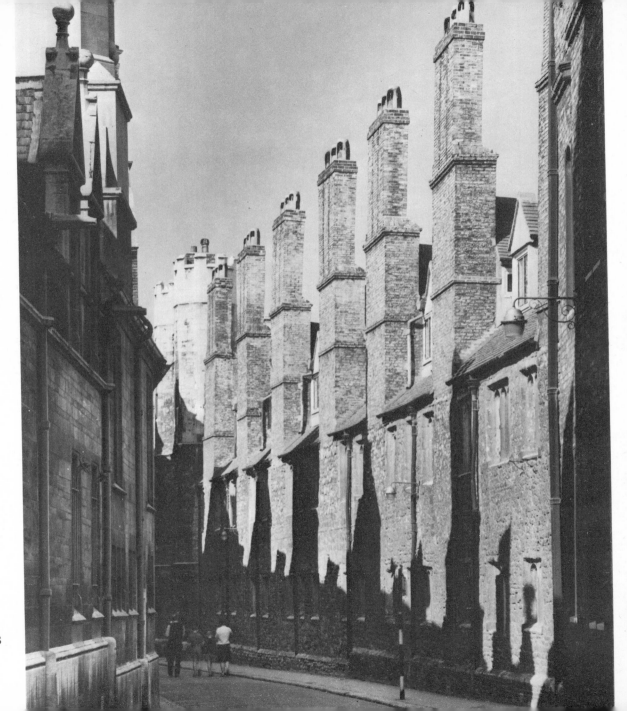

RHYTHM: Repetition of similar elements such as arches, windows, columns or chimneys brings unity to architecture and to a photograph, like a drum beat. Hence the well-known saying of Friedrich von Schelling 'Architecture is frozen music'. *Left*, Trinity Lane, Cambridge, England. *Below*, St James's Palace, London *(Both Linhof, wide angle)*.

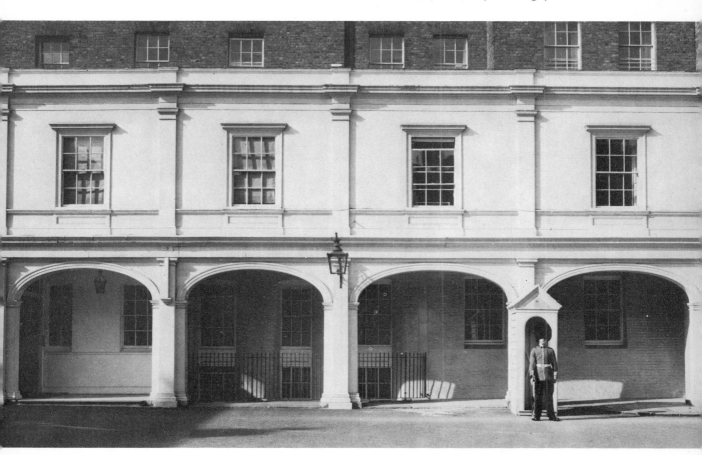

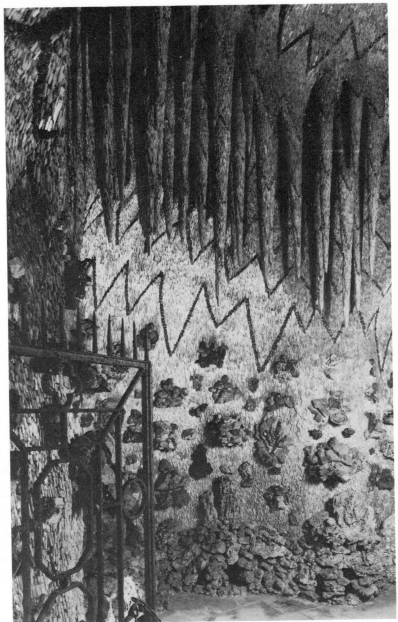

TEXTURE: This quality is most important in architectural photography, particularly in black-and-white. It can be stressed by strong side lighting, evening sunshine being often the best. *Right*, a detail of the world's finest and most intricate of eighteenth-century Divine Grots – that beside the lake at Ascot Place, England *(Linhof, medium lens)*. *Opposite*, rustication of the base of Louis Sullivan's Auditorium Building, Chicago *(John Szarkowski)*. The slightly blurred, moving figure serves both to provide scale and as a foil to the sharply defined, massive and richly textured solidarity of the great stones.

40

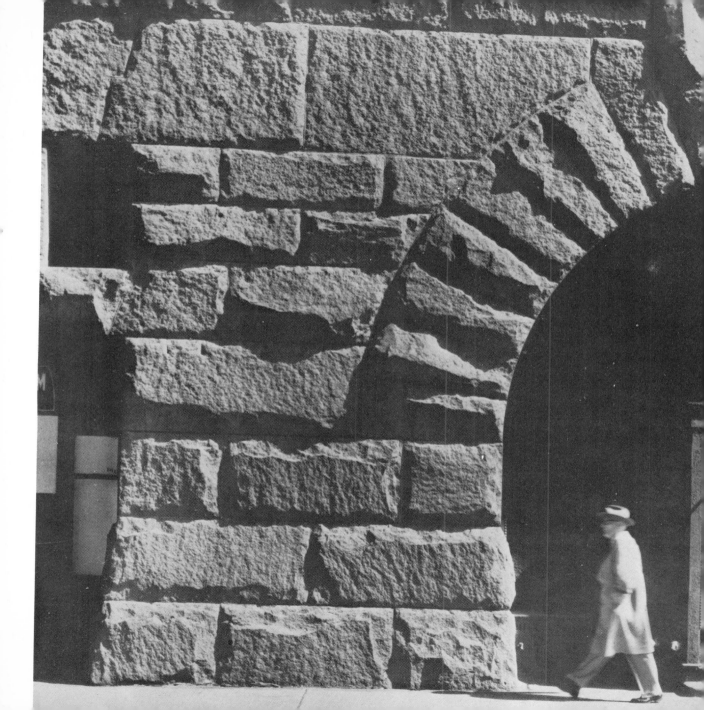

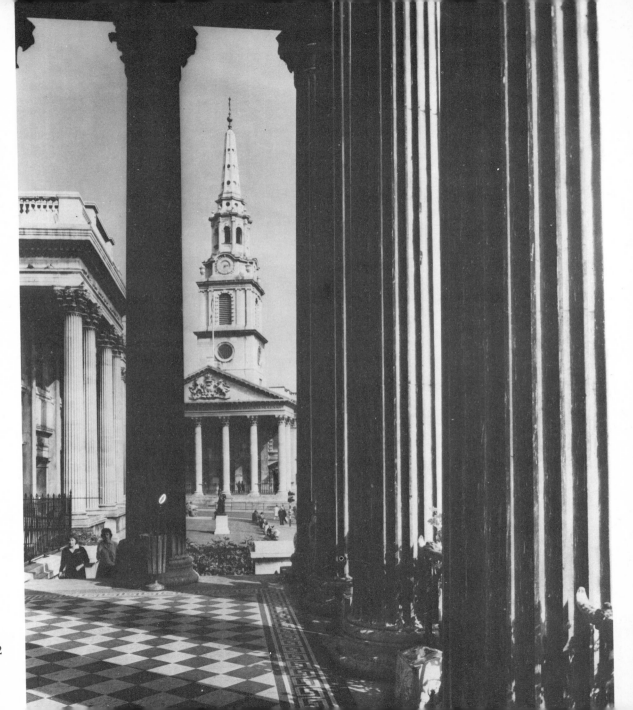

FRAMING: A trite way of framing is through an archway. Here are more interesting approaches. *Left*, St Martin-in-the-Fields Church, Trafalgar Square, London, seen through the columns of the porch of the National Gallery *(Linhof, wide angle)*. *Below*, a steel suspension footbridge of 1905 at Cambus-o'-May, Scotland, where one of the towers frames the other, so creating a monumental effect in a small, functional structure *(Rollei)*.

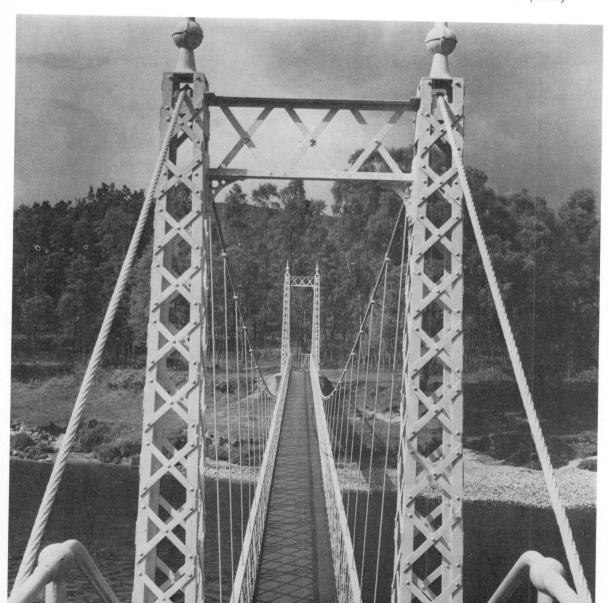

43

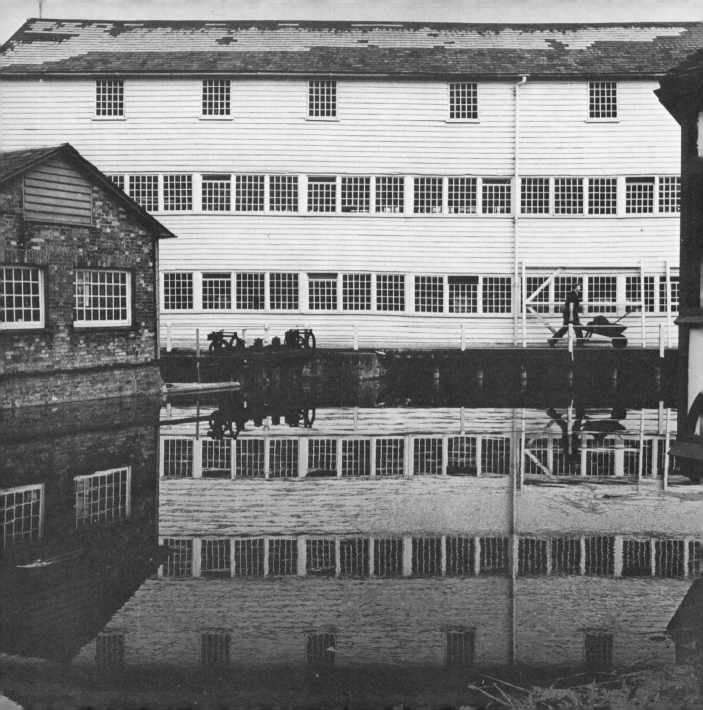

REFLECTIONS: Water, like large areas of glass, can serve as an attractive reflector. *Left*, a timber water-mill at Halstead, Essex, England *(Rollei)*. *Below*, The Vyne, near Basingstoke, an English country house, now under the National Trust, seen across a river in the low evening sunshine *(Rollei)*. Note the value of tree branches as foils to the building's geometry.

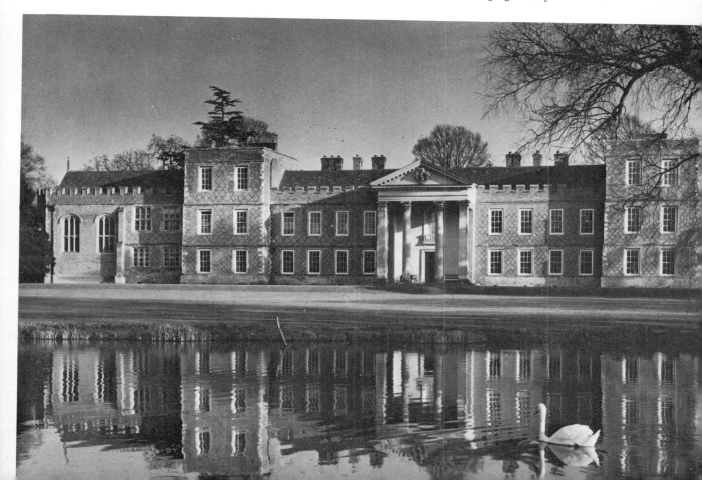

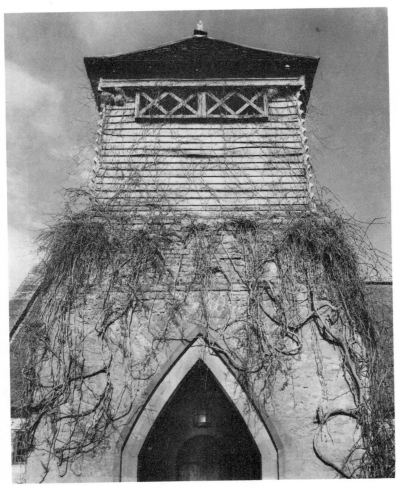

BRANCHES AS FOILS: Trees, foliage and branches provide fine baroque decoration on the geometry of structure. As a famous architect remarked, 'No architecture without trees'. *Left*, tower and entrance of Lethaby's Brockhampton Church, Herefordshire *(Linhof, medium lens)*. *Right*, Westchester, New York, 1931, a beautiful shot by the famed American photographer, Walker Evans.

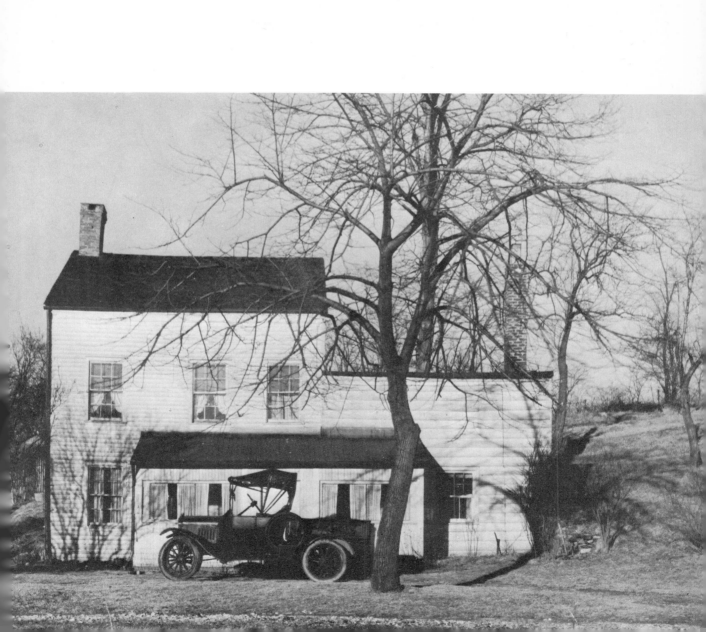

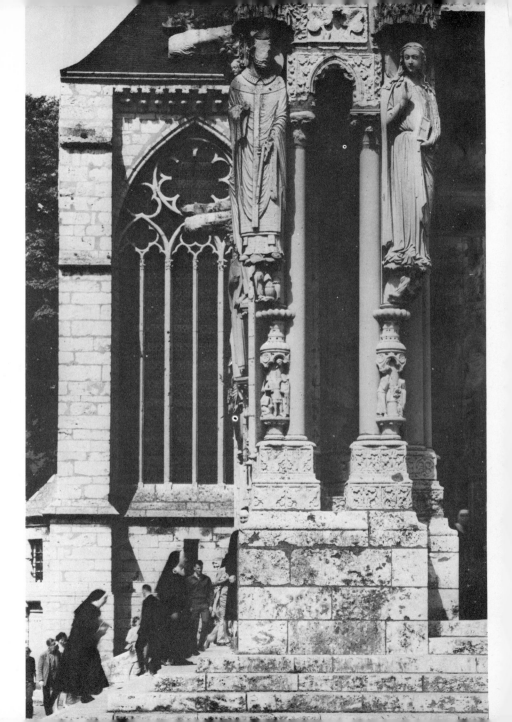

48

FIGURES AS FOCUS: Most pictures need a focal point, however subtle, that binds the whole composition together, to which all other elements are subservient and to which their lines tend to run. In an architectural photograph, a human figure or a group of figures can provide such a focal point; they also provide a sense of scale and size, and can make a static subject come alive. Figures can, of course, date a photograph on account of dress. They are very dominating for the eye is immediately attracted to them, and this domination should not be allowed to overwhelm the architectural subject. Never place a figure at or near the centre of a picture. *Left,* the north porch of Chartres Cathedral with appropriate ecclesiastical figures *(Linhof, wide angle, rising front)*. *Below,* old houses at Stratford-upon-Avon, England *(Rollei)*.

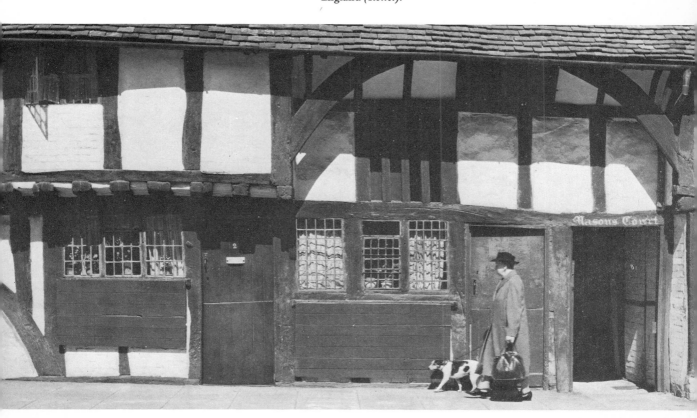

FIGURES AS FOCUS: *Right*, Boodle's Club,
St James's, London, with gentry.
Below, steps at Leeds University with
small figure giving scale and focal
interest. Architects: Chamberlin,
Powell and Bon *(Both Linhof, wide
angle).*

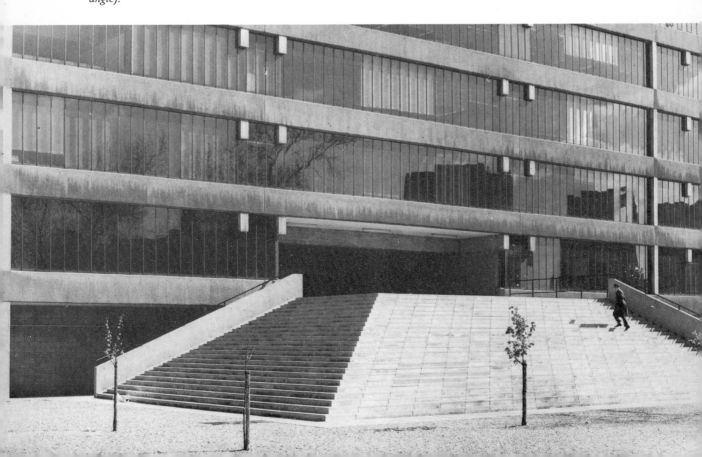

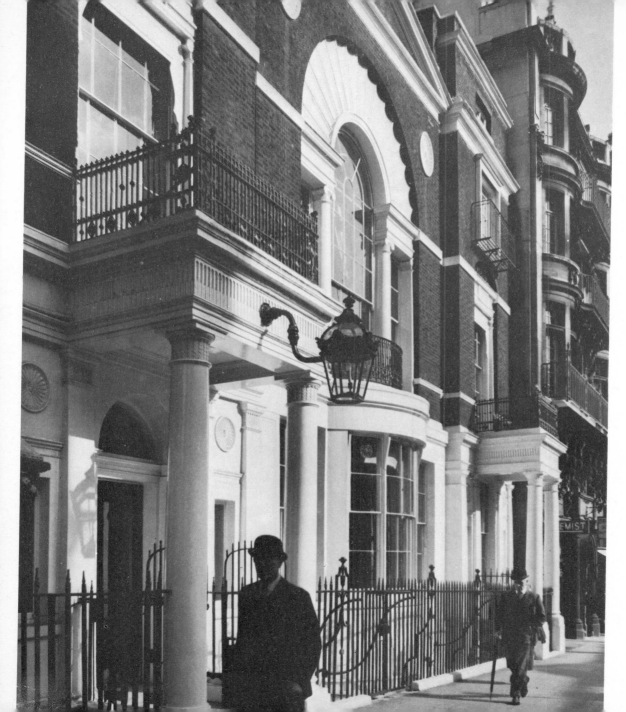

51

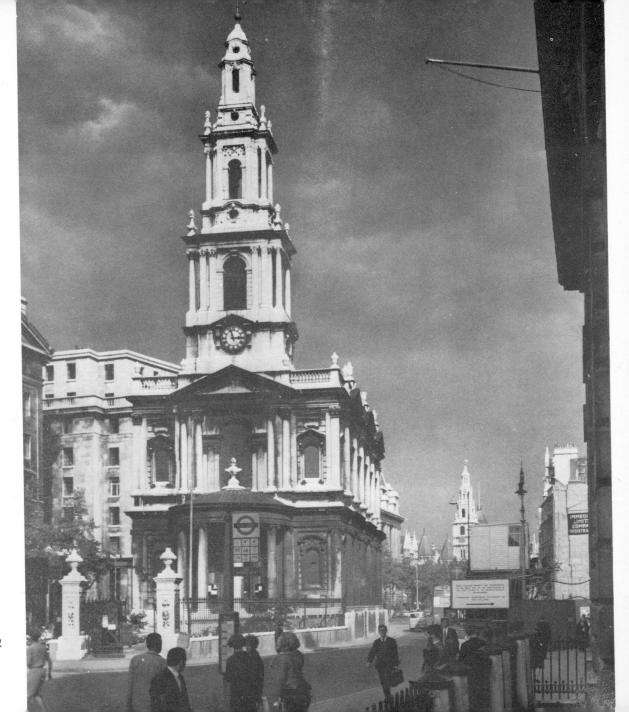

52

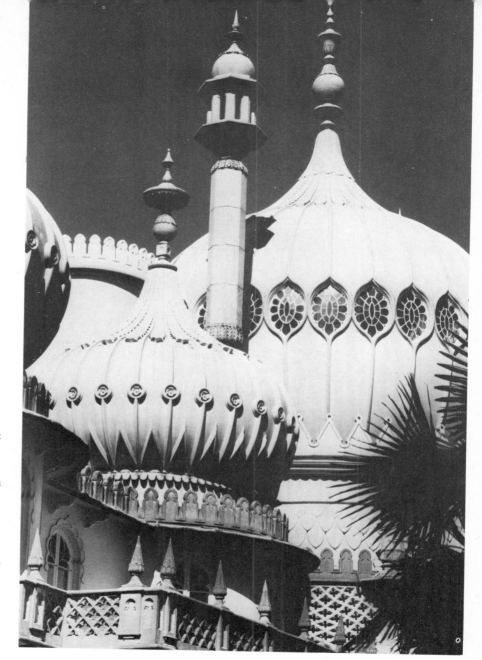

CHIAROSCURO: Sharp contrasts of light and shade can dramatize a building, and then the angle of sunlight is critical. Dark, stormy, and dark blue skies aid the drama, especially when a building is light in tone. *Left,* St Mary-le-Strand Church, London, taken against a thunder-black sky *(Linhof, medium lens). Right,* Indian domes and minaret only fifty miles from London – those of the Brighton Pavilion, the famous folly built for the indulgences of George IV *(Linhof, long focus, yellow filter).* Note that darkness of tone in the sky was obtained less by filtering than as a result of brilliant seaside atmosphere with sun shining well behind the camera.

54

WALLSCAPE: Here the selective, framing eye comes into its own to make interesting compositions with isolated parts of a building. Stressing textures is important. *Left,* a fortuitous case at Aix-en-Provence *(Rollei).* Here colour might have been appropriate and telling. *Right,* the fifteenth-century brick wall with its *ad hoc* fenestration at Queen's College, Cambridge *(Linhof, wide angle).*

FLOORSCAPE: Taking a shot against low evening sunlight helps to stress texture, but double exposure should then be given. *Right,* cobbles at Edinburgh Castle *(Rollei).* The figures are an essential part of the whole and show that the edge or corner of the picture is the most powerful place for the focal climax. Note its balancing on left with the widening sweep of the gutter. *Below,* a footway in Bideford, England, a well composed and richly textured shot by Gordon Cullen *(Rollei).*

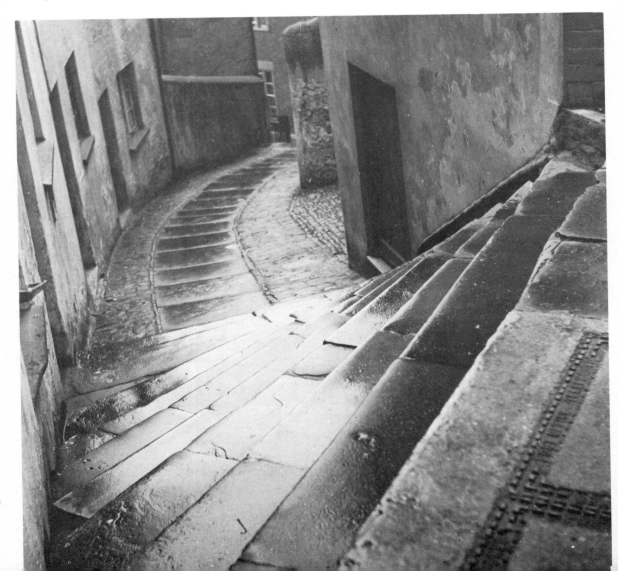

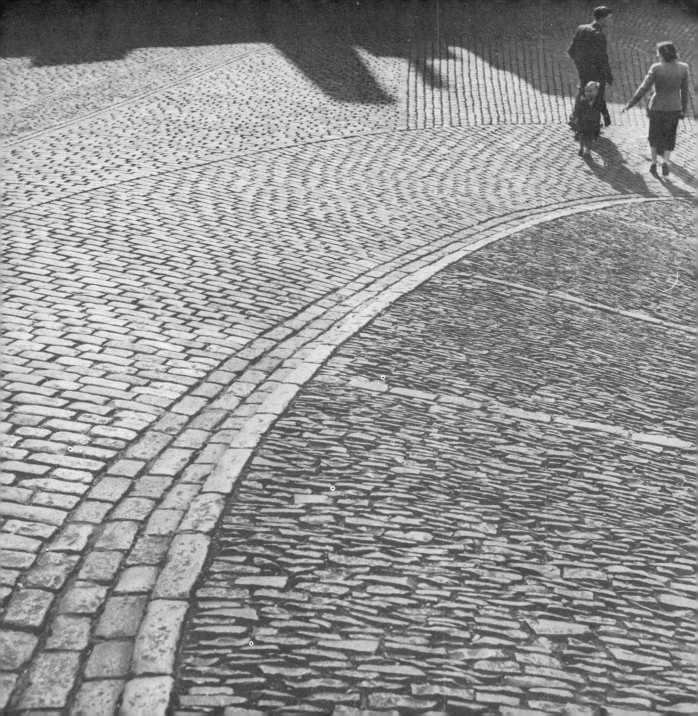

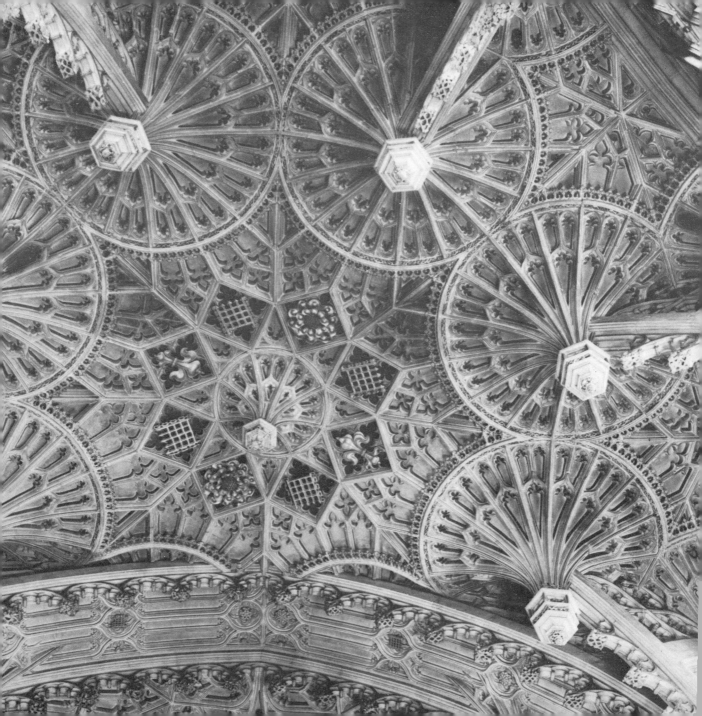

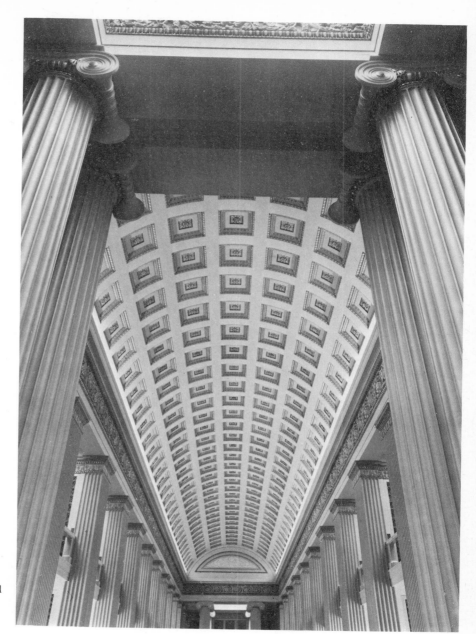

ROOFSCAPE: Worm's eye views of contrasting ceilings. *Left,* fan vaulting of Henry VII's Chapel, Westminster Abbey *(Linhof, wide angle, daylight mixed with two photoflood lamps). Right,* the barrel vault of the eighteenth-century library of Edinburgh University *(Linhof wide angle, available light).*

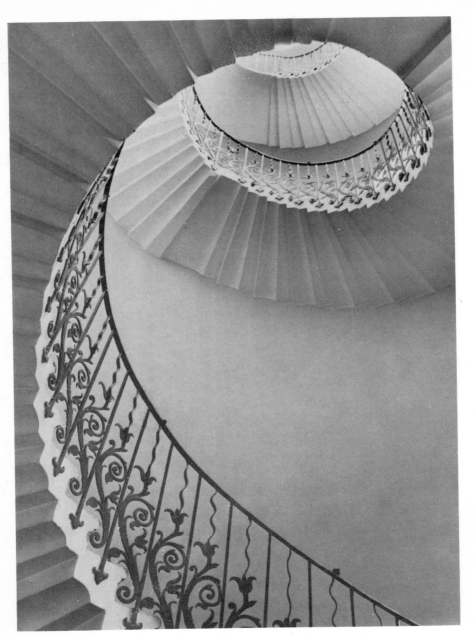

WORM'S EYE VIEW: The upward angle
must be wholehearted; nothing is
worse than weakly converging
verticals in an architectural shot.
Right, an almost 90° view of the
stairwell at a building at Birmingham
University (designed by the architec-
tural firm of HKPA) which creates a
strong abstract design. *Left,* the
Tulip Staircase in the Queen's House,
Greenwich *(Both Linhof, wide angle).*

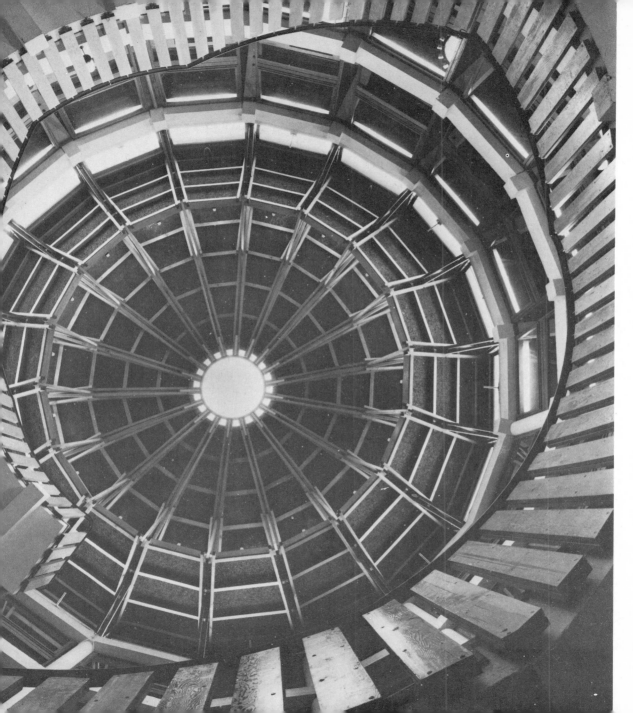

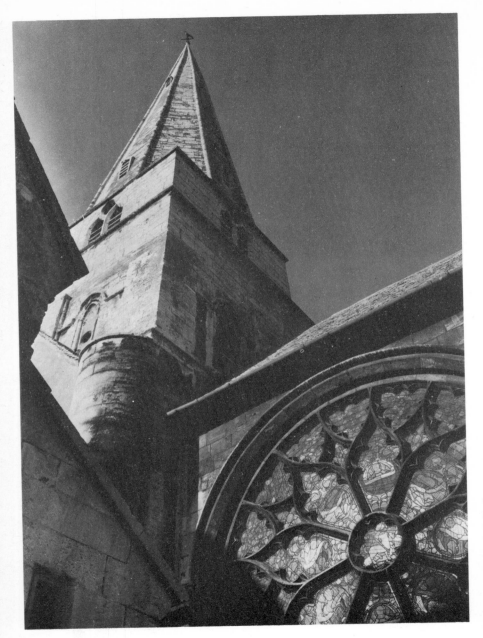

WORM'S EYE VIEW: *Right,* windmill
at Boston, Lincolnshire. Side lighting
stresses forms and textures, while
contrasting tones are produced by
white sail-frames against dark blue
sky obtained by camera angle plus a
yellow filter *(Rollei). Left,* parish
church at Cheltenham, England, with
symbolic *yin* and *yang (pace* St
Augustine) in steeple and rose window
(Linhof, wide angle).

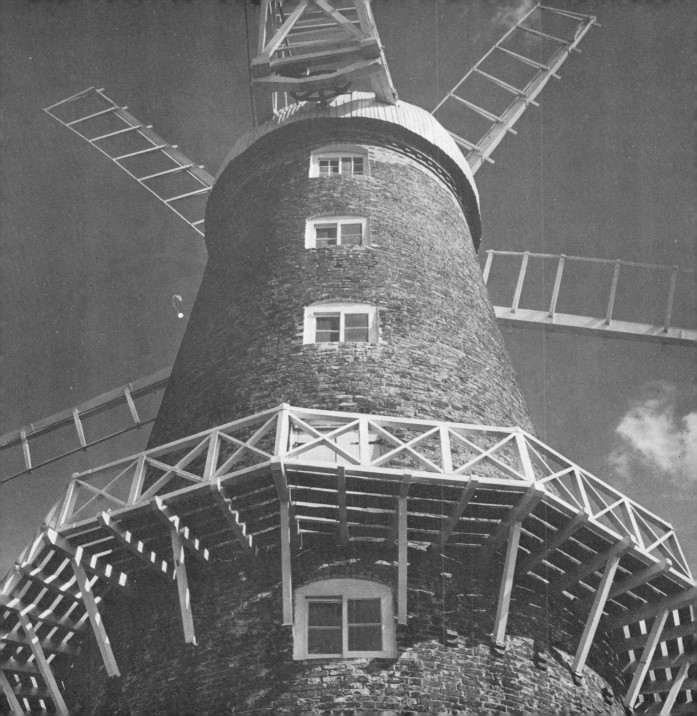

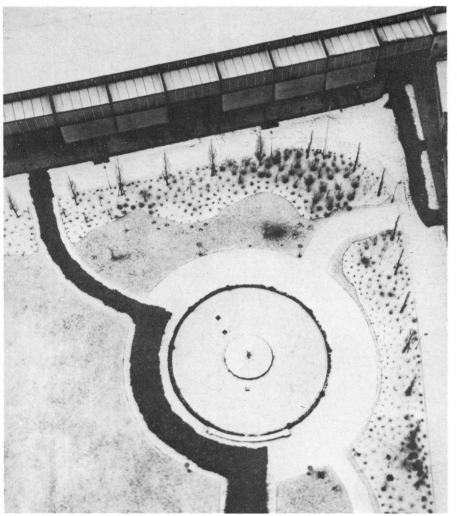

BIRD'S EYE VIEW: The camera, like the human eye, can look in any direction in search of interesting forms. *Left,* a well-known classic: wintry view from the Berlin Radio Tower, 1928, by the late Laszlo Moholy-Nagy. *Right,* the star shaped roof of St Saviour's Church, Copenhagen, taken from its tower *(Rollei).*

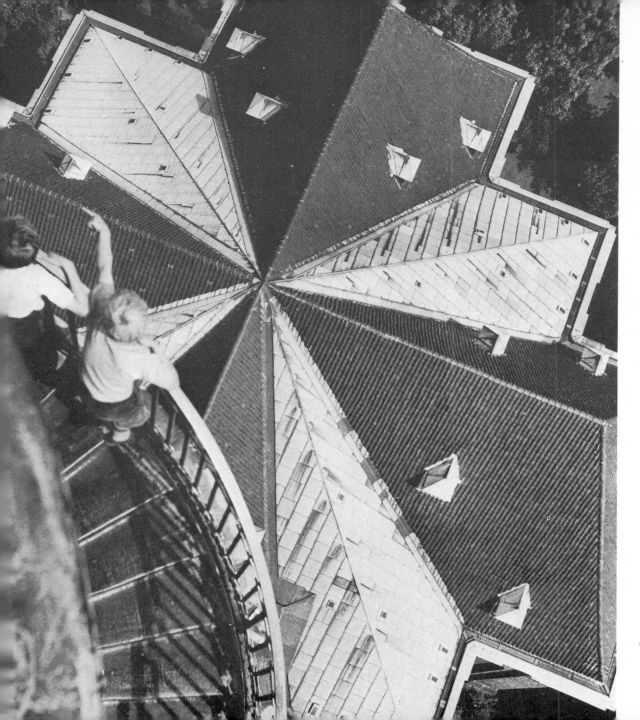

PLEASING DECAY: Old walls, ruins, and decaying materials can delight the Third Eye. *Below*, crumbling concrete fortifications built in the Second World War at Agde on the south coast of France, present a piece of unpremeditated sculpture like some stranded monster from the deep *(Linhof, wide angle)*. *Right*, the Propylea truncated and framed by the columns of the Erectheum on the Acropolis, Athens, taken by the distinguished American architectural photographer, G. E. Kidder Smith. A high rising front was obviously used here as well as a small diaphragm stop to cover the considerable depth of field.

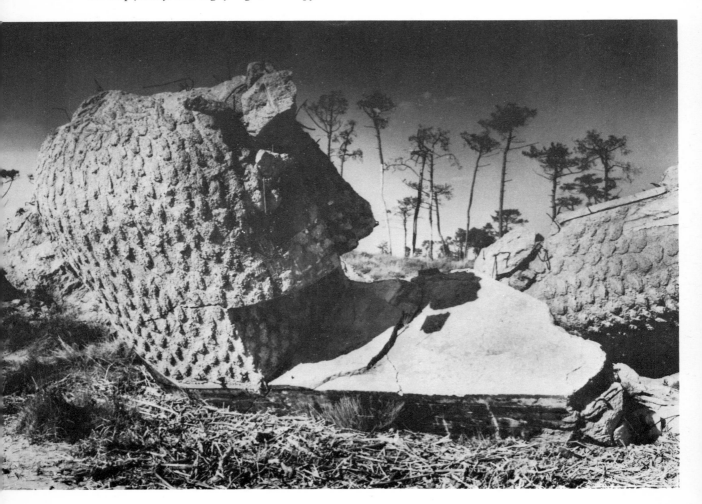

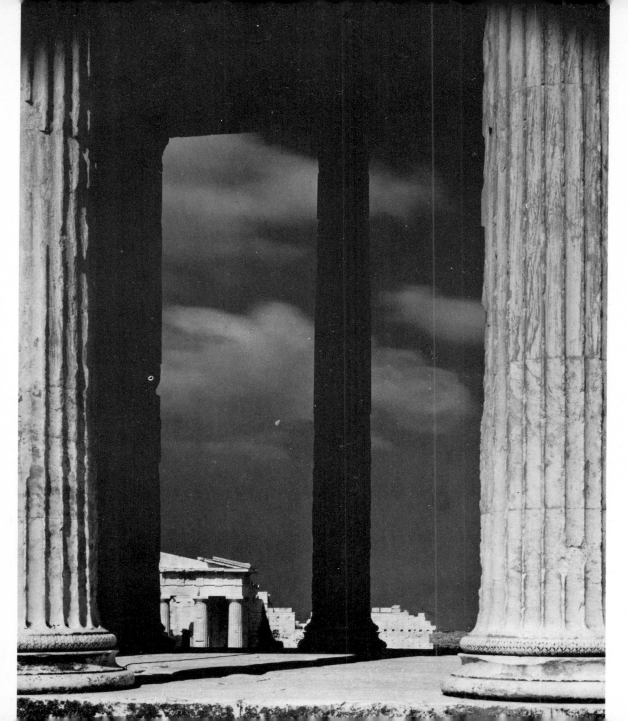

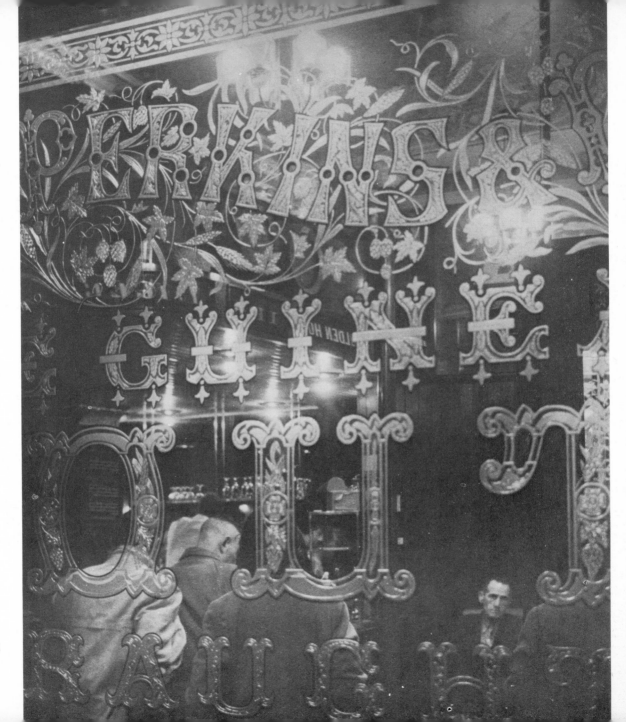

AT NIGHT: Photography at night, notably of floodlit buildings, presents no special difficulties in black-and-white. Give as long an exposure as you dare; at least double the exposure as revealed by a light meter, and if the exposure is fairly long quadruple it at least because the longer the exposure is the less will light affect the film emulsion owing to reciprocity failure. A tripod will almost certainly be needed. *Left,* the interior of a Victorian London pub taken on fast film in available light *(Rollei). Below,* a floodlit detail of Chiswick House, near London, including a statue of architect Inigo Jones *(Linhof, wide angle).*

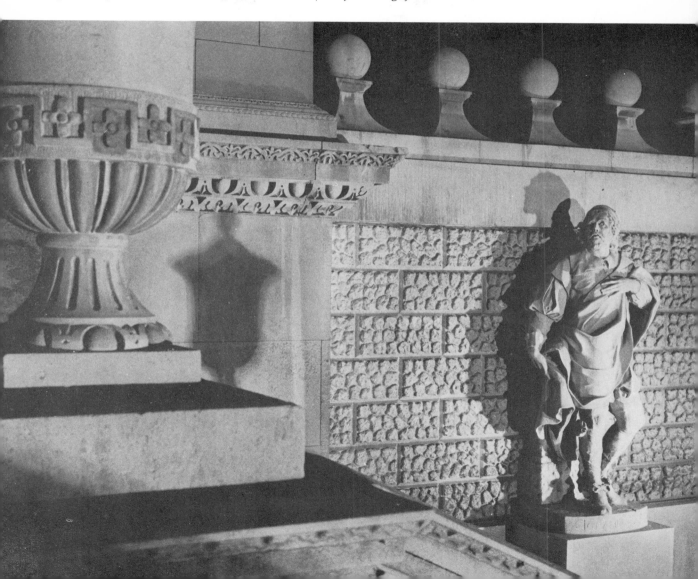

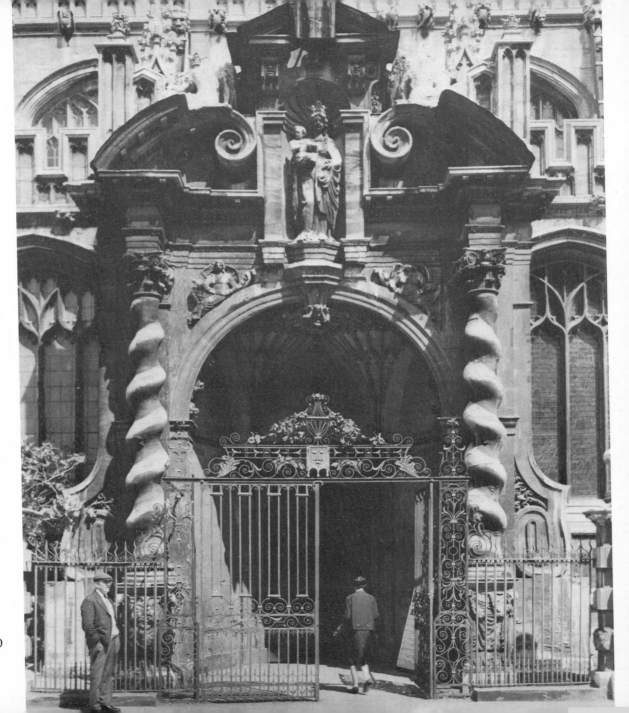

DETAIL: Selecting telling details and composing them carefully under suitable lighting is among the most satisfying forms of architectural photography. Here are two doorways of contrasting natures. *Left,* the baroque porch of St Mary-the-Virgin (1637) in the High, Oxford *(Linhof, medium lens). Below,* a tough, worn little utility entrance to a warehouse at Poole, England *(Rollei).*

DETAIL: Two windows in cultural and technical contrast. *Below,* the power house at Churchill Gardens, Pimlico, London *(Rollei). Right,* the great rose window on the west front of Chartres Cathedral *(Linhof, medium lens, rising front, only the upper part of the negative being printed).*

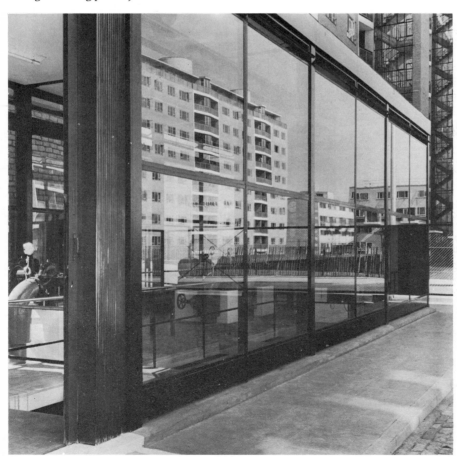

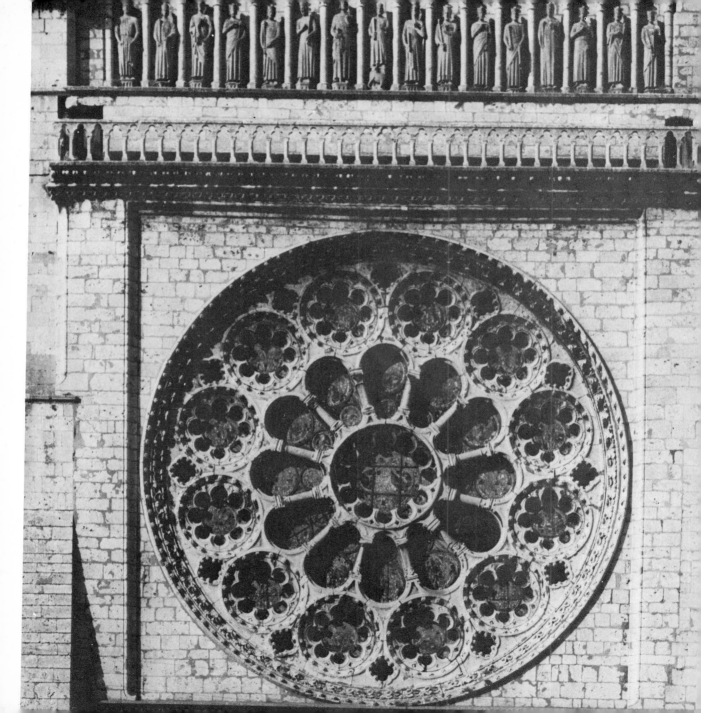

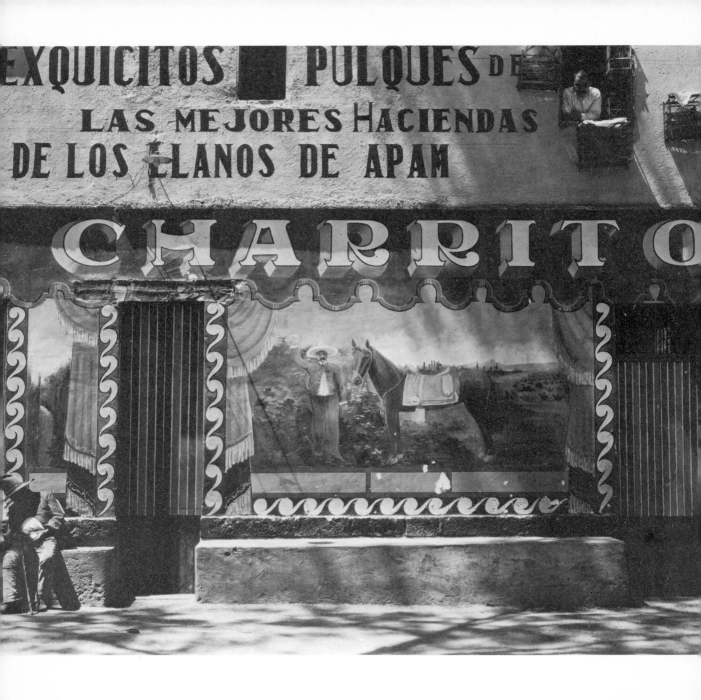

DETAIL: Applied decoration by pop
artists. *Left,* Pulgueria façade,
1926, by the distinguished American
photographer, Edward Weston. *Right,*
a child's charming graffito on a
building in Liverpool *(Rollei).*

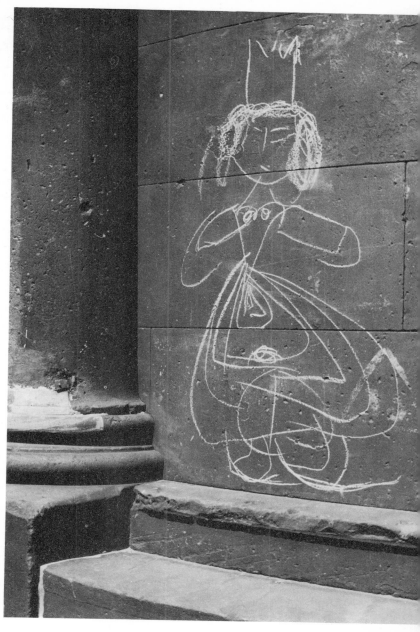

INTERIORS: A wide angle lens is almost essential. The main problem is avoidance of too much contrast in lighting. Large, carefully placed floodlamps with reflectors on adjustable stands are valuable. Avoid flash lighting unless no other lighting is available. *Below,* the concert hall at the Festival Hall, London, during an interval. A fast film and wide stop were used with one second's exposure, the whole audience being willed into stillness by extra-sensory means during that second *(Rollei). Right,* the stage of the concert hall in Liverpool Town Hall with its caryatids and other early Victorian details. Here two floodlamps with reflectors were used together with a small stop and fairly long exposure *(Linhof, wide angle).*

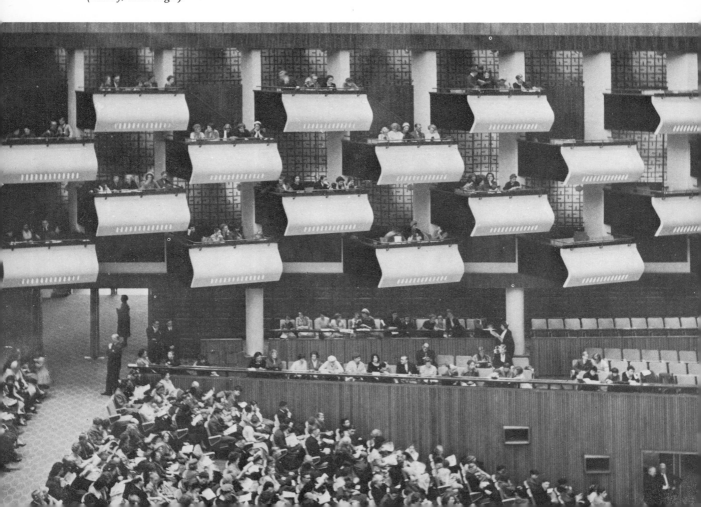

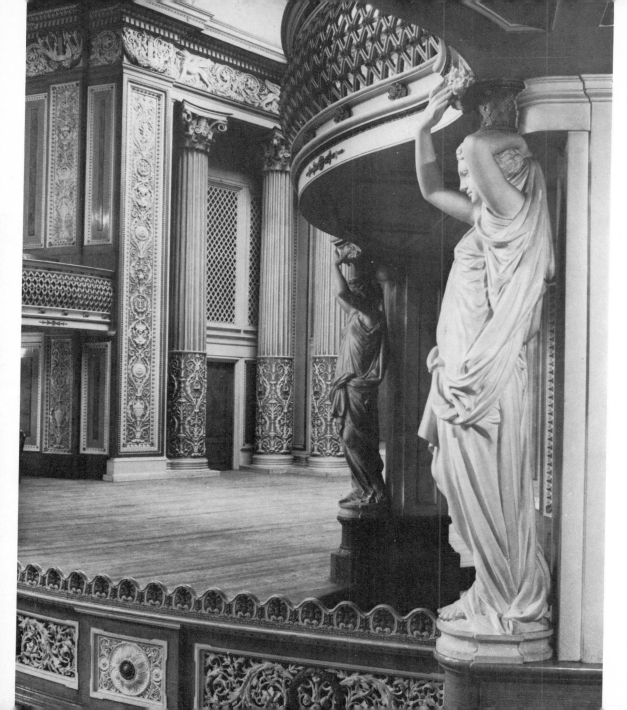

INTERIORS: *Below,* a cottage bedroom in
Cornwall lit by a single floodlamp at
dusk so that the view of the coast
outside would not be over-exposed but
would look like a picture on the wall
(Linhof, wide angle). Right, the fine
library at Queen's College, Oxford,
attributed to Wren *(Linhof, wide angle).*
Spatial relationships of interiors can
only be implied in photographs; the
moving body itself is the only means
by which complex interiors can be
fully appreciated.

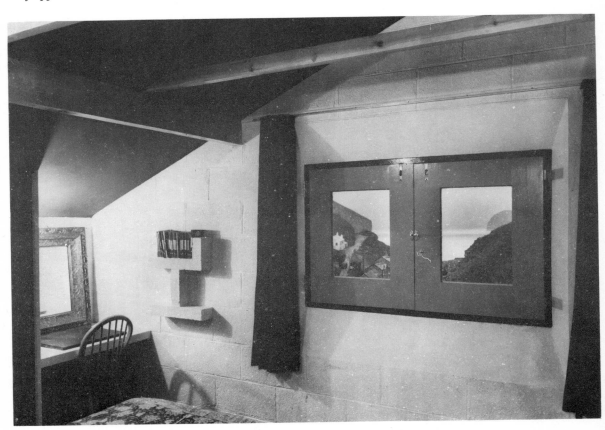

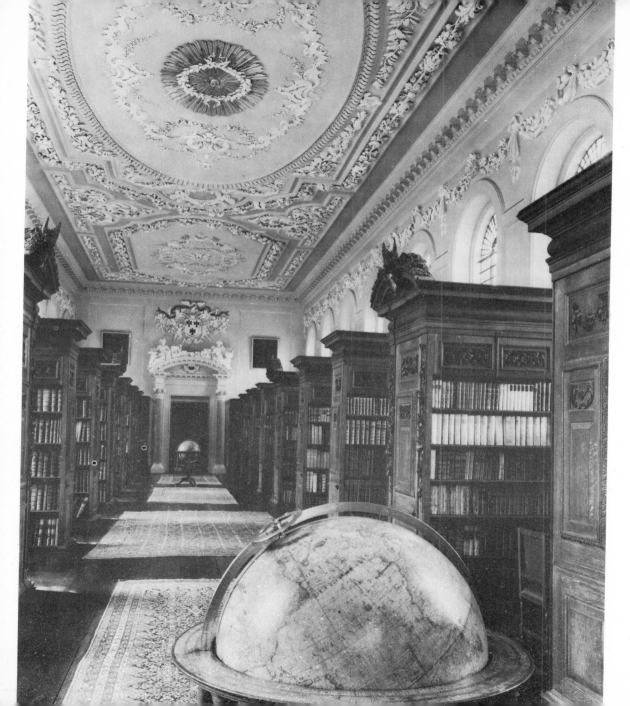

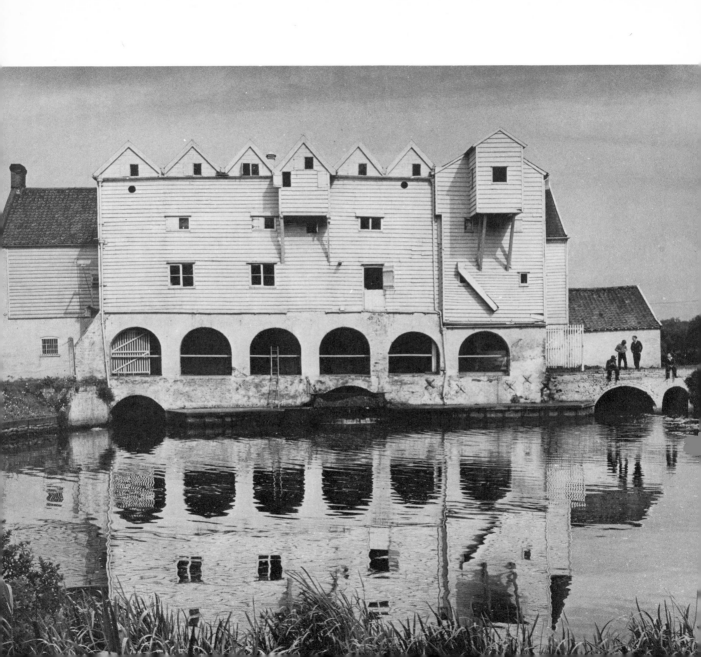

ARCHITECTURE WITHOUT ARCHITECTS:
Many functional structures achieve
architectural status without self-
conscious, stylistic designing by a
member of the learned profession.
Engineers, shipwrights, and
anonymous local builders have often
produced structures of great beauty
without architectural training.
Left, a Norfolk watermill of
white-painted timber which died in a
fire some years ago. *Right,* the stern of
Nelson's flagship *Victory*, at
Portsmouth Naval Dockyard, in
which the sash window went to sea
(Both Rollei).

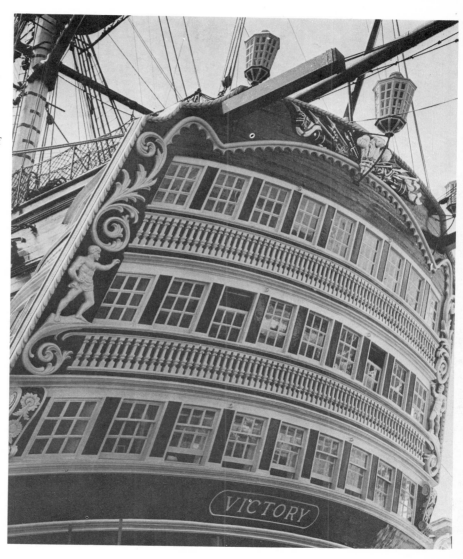

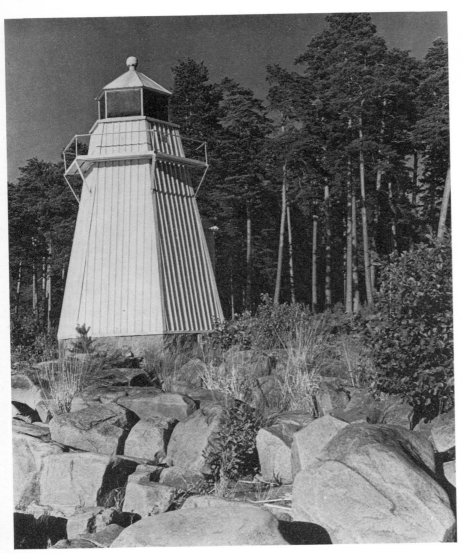

ARCHITECTURE WITHOUT ARCHITECTS:
Left, an exquisite but utterly
functional little timber lighthouse on a
lakeside in central Sweden. *Right,*
fishermen's storehouses at Hastings,
England, rich in timbered textures,
form a miniature Manhattan *(Both
Rollei).*

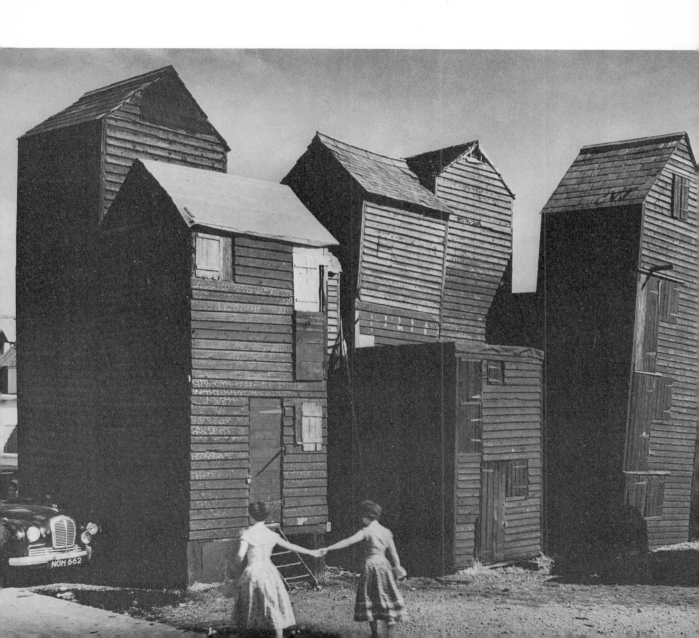

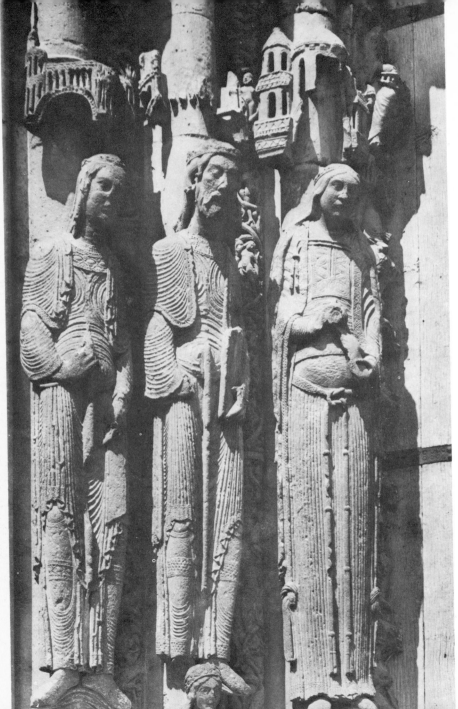

SCULPTURE BY DESIGN: Sculpture at its best is integrated with architecture as at Chartres Cathedral where, *Left,* these superb, formalized figures decorate the reveals of the doors on the west front *(Linhof, wide angle).* As an easle painting is to a fresco, so a piece of sculpture may also be freestanding rather than integral and serve as a decorative feature in an interior. Fine examples can be found in the tombs and monuments of English cathedrals and old country churches. *Right,* the Dancing Knight at Dorchester Abbey Church, Oxfordshire, a vigorous and beautifully formalized example of mediaeval art *(Rollei, available light).*

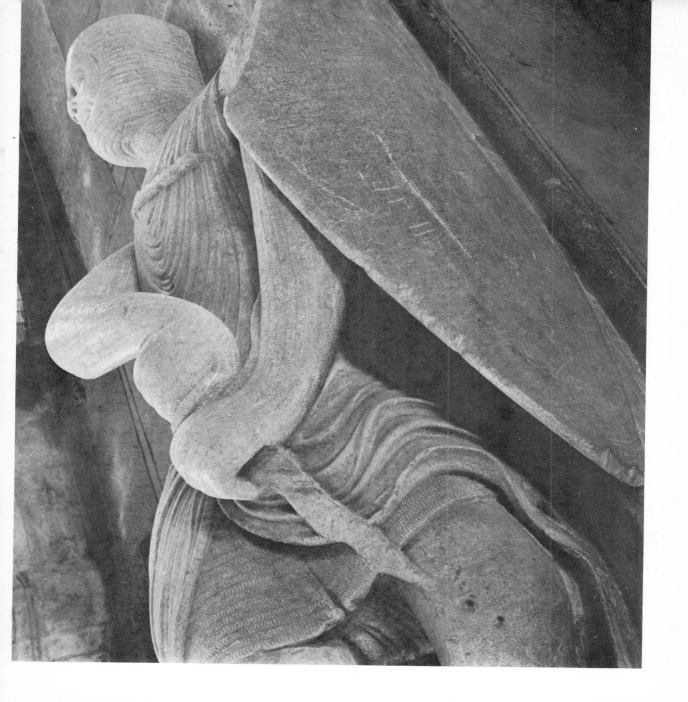

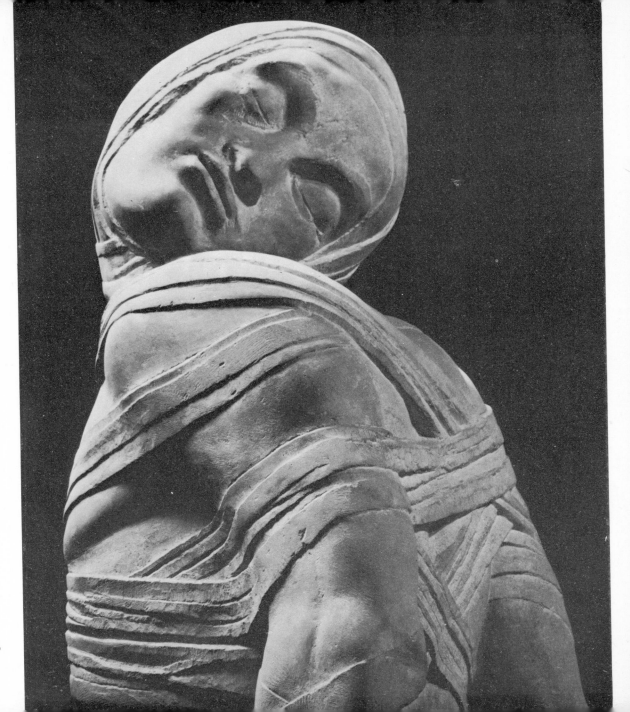

SCULPTURE BY DESIGN: Two more freestanding examples. *Left*, detail of Lazarus in the ante-chapel of New College, Oxford, one of Epstein's best pieces. Available light, showing that the object has been well placed *(Linhof, medium lens)*. *Below,* head of Amun, Temple of Karnak, Egypt, by G. E. Kidder Smith; a dramatic shot taken from below and emphasizing tones, forms and textures.

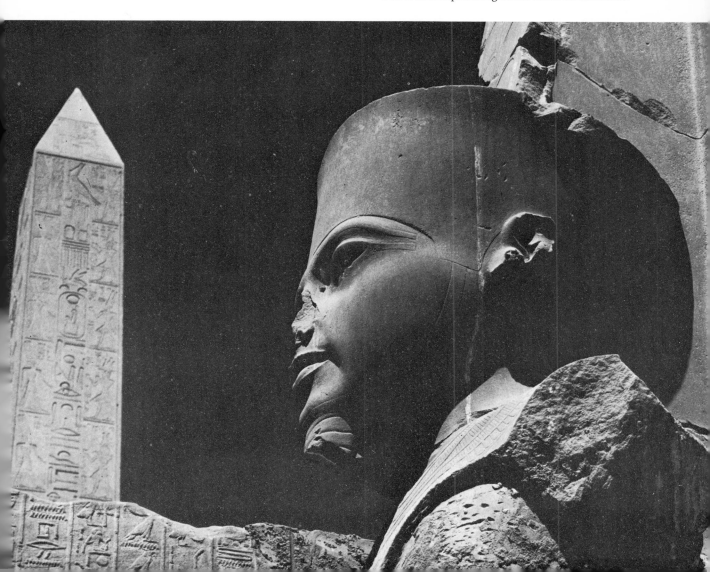

SCULPTURE BY DESIGN: *Below,* the majestic head of Queen Elizabeth I on a tomb in Westminster Abbey *(Rollei). Right,* a luscious and highly competent Victorian piece of unknown origin found in a Kensington basement *(Linhof, wide-eye).* Both in available light.

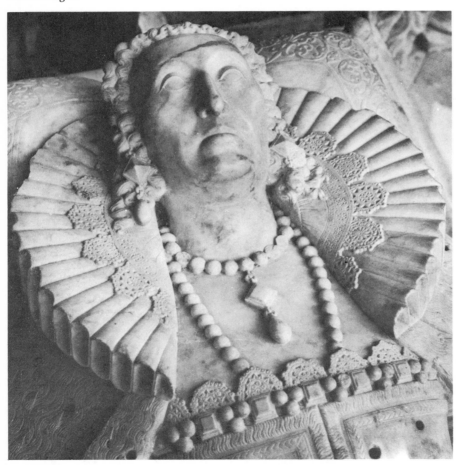

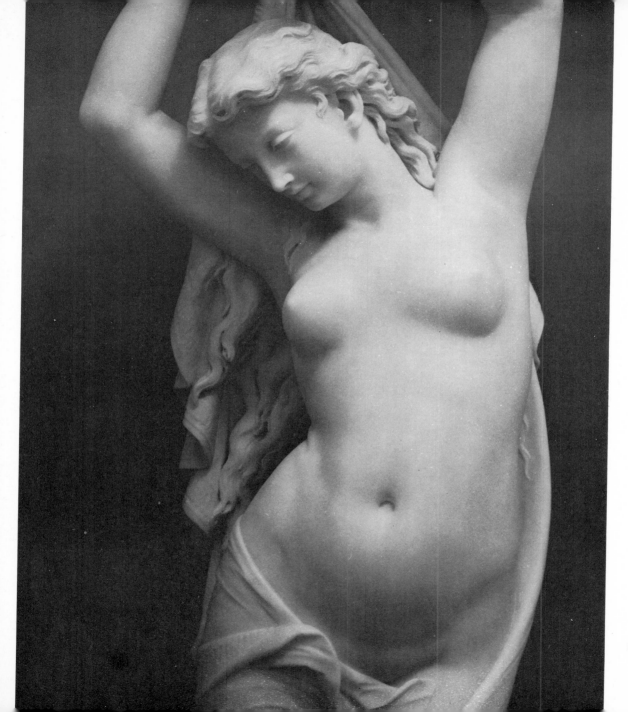

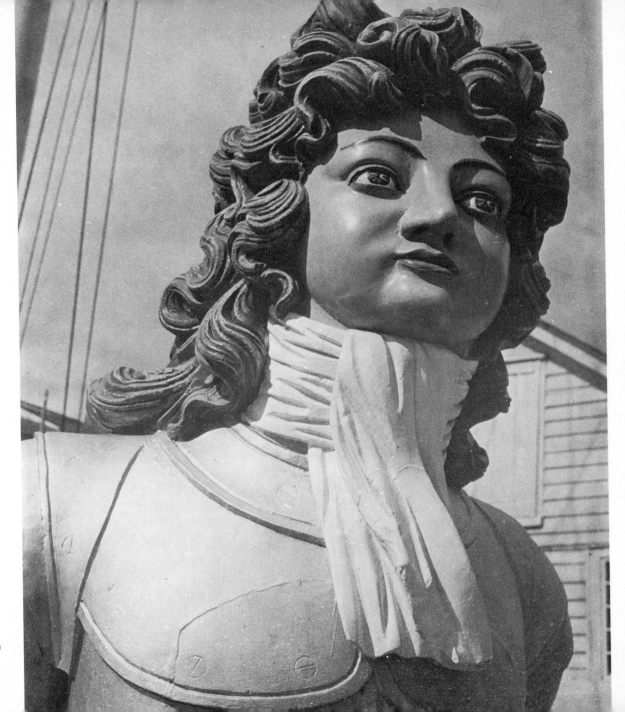

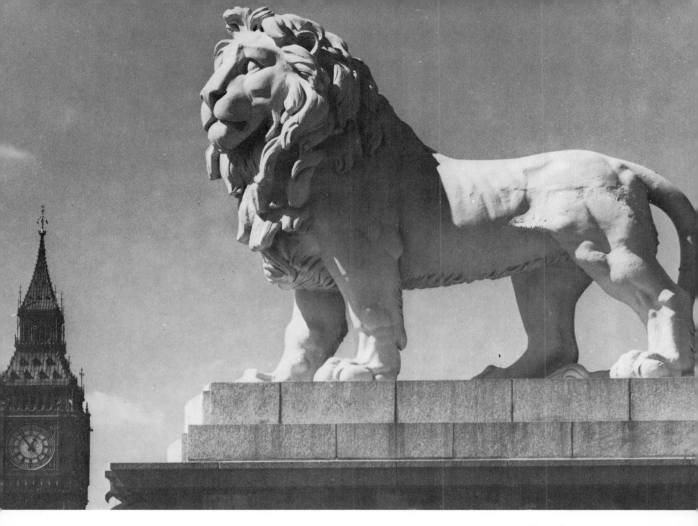

SCULPTURE DISPLACED: Two pieces which were once integral details of structures. *Opposite*, a debonair ship's figurehead at Portsmouth Naval Dockyard *(Rollei). Above,* the lion now on a pedestal at the eastern approach to Westminster Bridge, London once graced the top of a local riverside brewery *(Linhof, long focus).* The tower of Big Ben is in the distance.

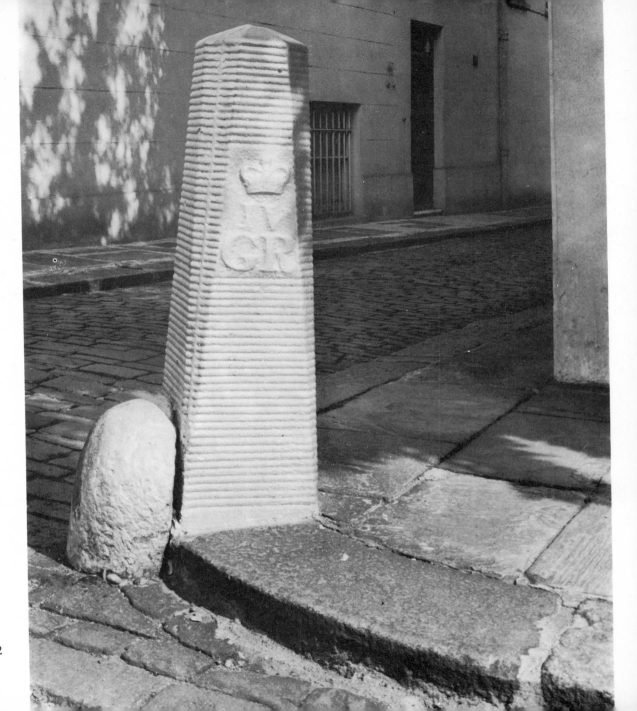

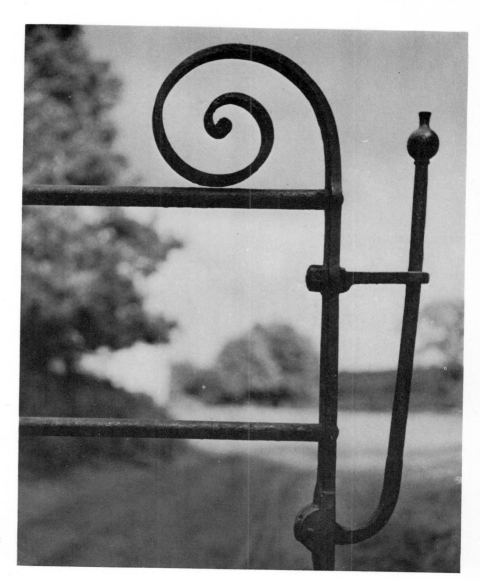

SCULPTURE BY ACCIDENT: The adventurous photographer can discover unintended sculptural qualities in functional objects everywhere, and he may enjoy making collections of certain kinds, perhaps old lamps, bollasters, bollards, coal-hole covers, keystones, doorways, fanlights, door knockers *et al. Left,* a Georgian street bollaster of iron near Regent's Park, London *(Rollei). Right,* a farm gate latch of iron somewhere in England *(Rollei). Overleaf,* detail of the side of the late Lord Lonsdale's landaulet possessing qualities that are both sculptural and architectural *(Rollei).*

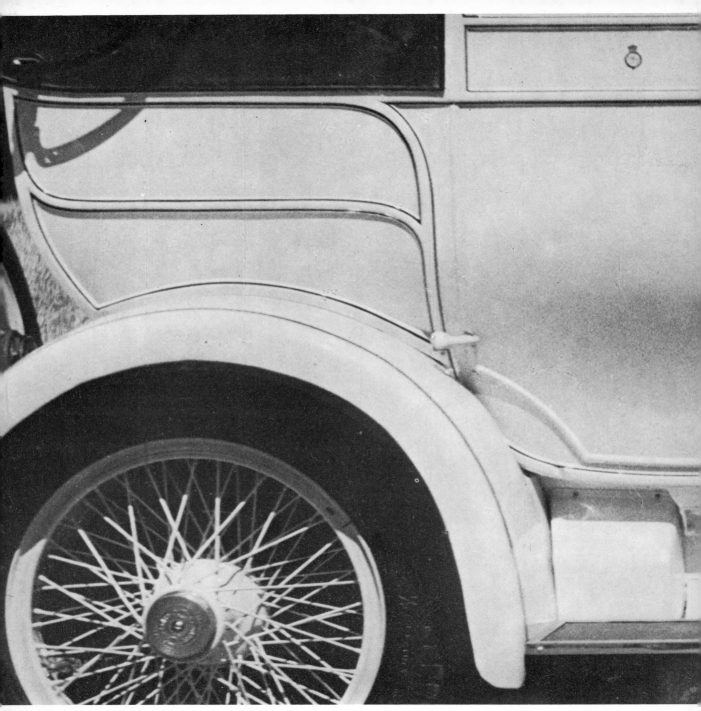

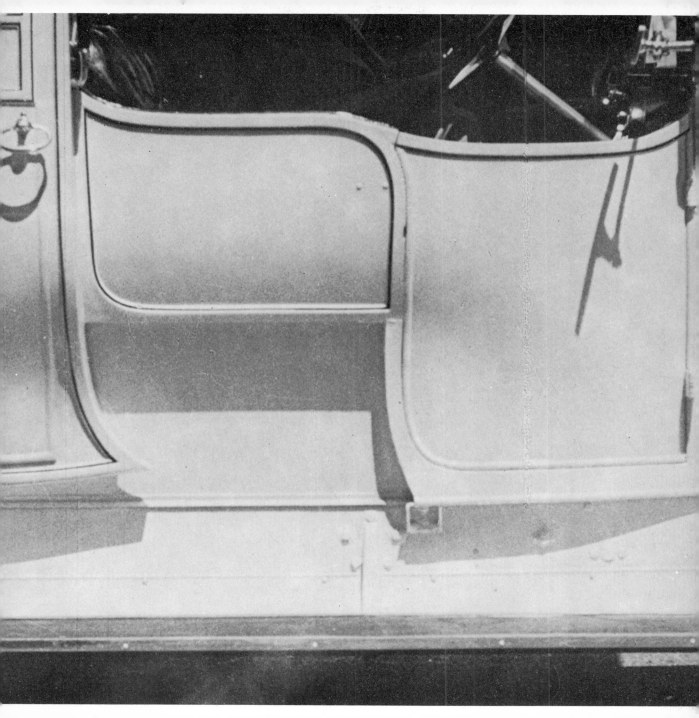

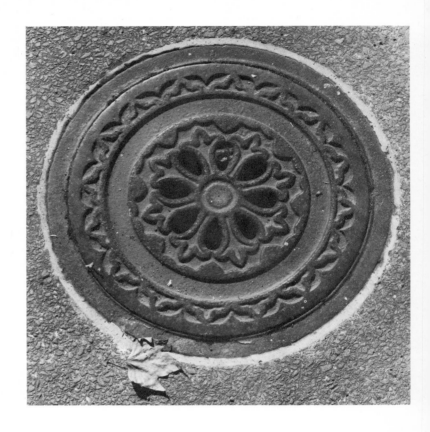

SCULPTURE BY ACCIDENT: A London
operculum, or Victorian coal-hole
cover, like a small rose window,
brings this book to its full stop.